THE FANTASTIC FLOWERS OF
CLARICE CLIFF

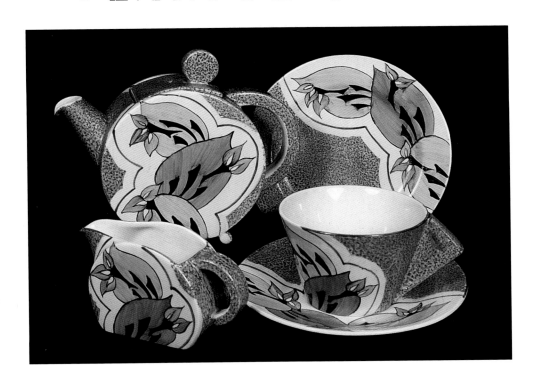

THE FANTASTIC FLOWERS OF
CLARICE CLIFF

A CELEBRATION OF HER FLORAL DESIGNS

LEONARD GRIFFIN

PHOTOGRAPHY BY MICHAEL SLANEY AND LEONARD GRIFFIN

HARRY N. ABRAMS, INC., PUBLISHERS

To each and every one of Clarice's 'flower girls'

Designed by Nigel Partridge

ISBN 0-8109-1183-3

First published in Great Britain in 1998 by Pavilion Books Limited, London

Published in 1999 by Harry N. Abrams, Incorporated, New York

Printed and bound in Singapore

Harry N. Abrams, Inc.
100 Fifth Avenue
New York, N.Y. 10011
www.abramsbooks.com

CONTENTS

WITHDRAWN

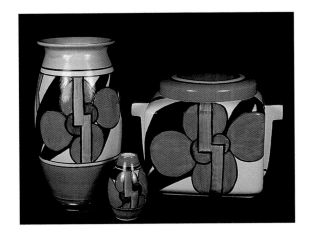

CLARICE CLIFF'S ROOTS

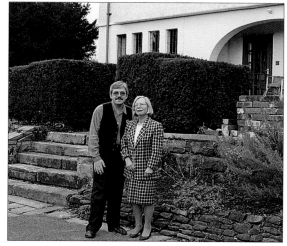

Clarice Cliff's artistic individuality is so strong that, although her designs and shapes encompass many styles, now as in the thirties people exclaim 'Clarice Cliff!' upon seeing them. With little formal training she emerged as the most productive and prolific ceramics designer of her generation. The worldly wisdom of Colley Shorter, her mentor, then lover and eventually husband, led to the skilful and lucrative marketing of her imaginative wares. It was extraordinary that her most successful years mirrored those of the Depression. The total of one hundred *Bizarre* 'girls' she employed testifies that her unique ware generated phenomenal sales in Britain and overseas at a time when the whole world was suffering from the Depression of the thirties.

Clarice's startling Art Deco designs and shapes are unmistakable but her art was founded on a simpler concept than that of rigorous squares, circles and triangles. It evolved from an everyday appreciation of colour fuelled from nature. For the first time, her niece Nancy has shared her memories of the woman who was the first female Art Director in the Potteries, but who to her was simply 'Auntie Clarice'. Thanks to her reminiscences, we now know Clarice treasured memories of childhood walks in the Staffordshire countryside. Even in the hectic thirties she sought inspiration there whenever she could. As Clarice was unable to see Colley Shorter at weekends, 'Nance' – as Clarice always called her – was her chosen companion. We are now able to understand more fully the complex life behind Clarice Cliff's seemingly uncomplicated art. Clarice's floral inspiration came from both her vivid imagination and her love of nature. This is the key to understanding why she produced ware that combined sophisticated Art Deco shapes with floral patterns. Previously, designers had used soft pastel shades that homogenized the true colours of the flowers. Clarice Cliff was the first to make flowers big, bold and bright. Her extreme florals bear only a passing resemblance to the real

Above: Professor Flavia Swann, the present owner of Chetwynd House, with the author in 1997.

Opposite: Clarice Cliff in her garden at Chetwynd House in 1949 photographed by Colley Shorter.

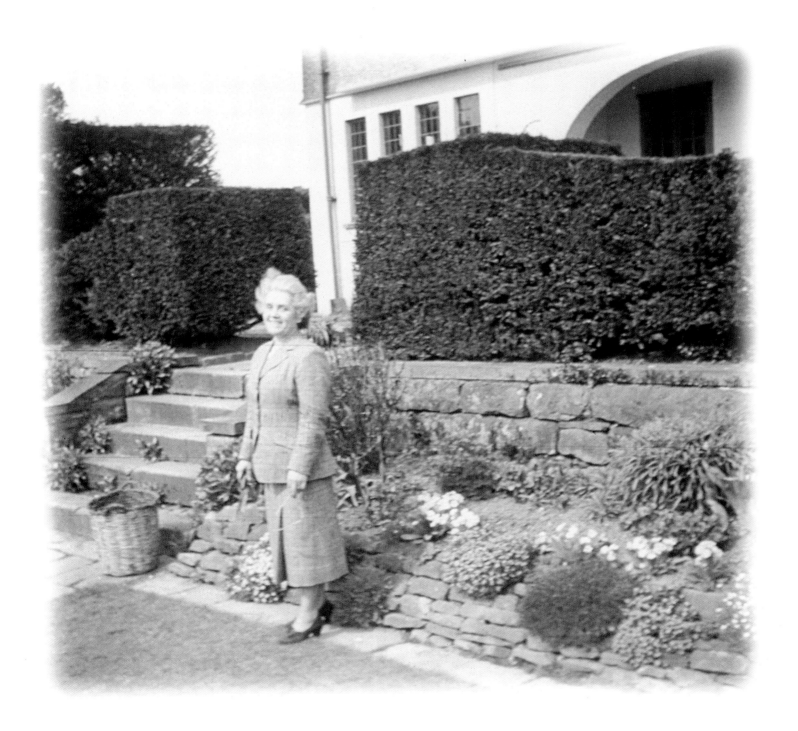

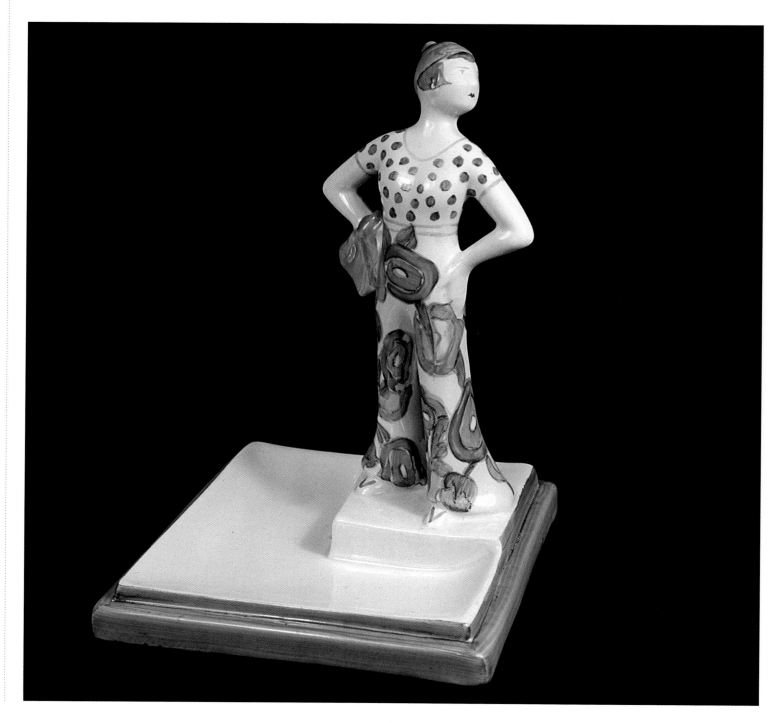

thing: her *Gardenia* was not white, but coral red or orange, and the leaves on *Latona Red Roses* were not green but black!

Adventurous to the last with her shapes, designs and colours, we might be tempted to view Clarice as the flamboyant character on her *Lido Lady* ashtray, but she remained a quiet person at heart. Her weekdays, spent in the spotlight of publicity meeting royalty and personalities, contrasted with her weekends when, back home, she was just a typical Staffordshire woman. Clarice's passion for colour and form in her pottery was balanced by a down-to-earth personality. Nancy recalls 'visiting the library to get romance novels for Auntie Clarice, and the corner sweet shop for a quarter pound of treacle toffee to aid her reading!' The escapist novels Clarice devoured at weekends were light relief compared to the library of flower and design books kept under lock and key in her Newport Pottery studio.

When the Second World War started Clarice faced an uncertain future with her design skills redundant. Then, in a real-life story more fantastic than the novels she avidly read, the death of Colley Shorter's wife finally left him free to marry her. Thus, fate united her with the Arts and Crafts home built in the year of her birth, and Clarice became mistress of Chetwynd House. She devoted herself to looking after Colley and the house they passionately loved. However, it was the four-and-a-half-acre hillside garden that was to dominate much of their time. Clarice had her own piece of countryside, and could now grow the same flowers her 'girls' had painted on *Bizarre* ware. Arches were heavy with vivid red roses, and the groomed borders were full of delphiniums, Canterbury bells and dahlias.

Clarice and Colley's garden is long gone, but fortunately they were both keen photographers and captured a colourful diary of the garden throughout the seasons with a stereoscopic camera. Their photographs, and a rediscovered cache of Clarice's letters, confirm that she loved flowers and the Staffordshire countryside, and devoted herself to them. The garden lives on in their photographs, and I am pleased to be able to share it with you for the first time. We now have a more personal insight into the still intriguing Clarice Cliff: an Art Deco lady in her own English country garden.

LEONARD GRIFFIN

ABOVE: CLARICE CLIFF'S NIECE NANCY RELAXING IN THE YARD AT THE FAMILY HOME IN TUNSTALL IN 1928.

LEFT: A LIDO LADY ASHTRAY SHAPE 561 WITH HER 'BEACH PYJAMAS' DECORATED IN BLUE CHINTZ.

CLARICE AND COLLEY

Britain's most prolific ceramics designer in the thirties was to owe much of her success to the belief shown in her by Colley Shorter, a formidable yet flamboyant Victorian gentleman. From the middle of the twenties he was the owner of Chetwynd House, built in the Arts and Crafts style on an open green hillside in the country village of Clayton in 1899. In the same year, Clarice Cliff was born in a terraced house in Meir Street, Tunstall, amidst the dirt and smog of the hundreds of bottle ovens that dominated the Potteries. The two houses represented the extremes of Staffordshire life, but Clarice's unique abilities, helped by fate, meant that by the time she was forty she was both a well-known designer and also mistress of Chetwynd House. Her success was achieved through her appropriately named *Bizarre* ware manufactured at Newport Pottery at Burslem, just a few miles from both Clayton and Tunstall. The owner of the factory and the house, Colley Shorter, became the most important person in her entire life.

Arthur Colley Austin Shorter was born in 1882 into a wealthy Potteries family. He was the first son in a family of six children born to Arthur and Henrietta Shorter. Having his father's first name, he was known as 'Mr Colley' by his employees. Well educated, lean and handsome, his youthful passion was for sport. This was surpassed by an even greater enthusiasm for the family businesses – Shorter & Sons in Copeland Street, founded in 1878, and A.J. Wilkinson's at Newport, Burslem, which Arthur Shorter had purchased in 1894. Four years later Colley joined Wilkinson's and his father trained him in all the disciplines of making and selling pottery. By the time he was twenty-five he had travelled to stockists as far away as America and Canada, in those days an arduous journey by sea and rail taking many days.

Colley Shorter was a man of boundless energy and enthusiasm. His extrovert personality was reflected in his love of expensive motor cars and foxhunting. He was a prominent freemason, and developed a lifelong passion for antique furniture, fine porcelain and Oriental art. His younger, quieter brother Guy, who had been managing the Shorter factory, joined Wilkinson's as a manager in 1905. Shortly after, Colley married Annie Rogers, and they lived in the desirable suburb of Wolstanton, calling their home Chetwynd House. Their first child, Margaret, was born in 1912. Colley and Guy were both made directors of Wilkinson's in 1916 – the same year that Clarice Cliff joined as an apprentice lithographer. In 1918 Arthur Shorter retired and moved to Llandudno, leaving his sons in charge of his factories.

At the end of the First World War there was an enormous

RIGHT: FANTASQUE RED TULIP ON A 13" WALL PLAQUE, 1930.

boom in the pottery industry. Of all the Shorter brothers' companies, Wilkinson's produced the most prestigious items in the form of *Oriflamme, Tibetan* and *Rubaiyat* ware, but a world-wide market wanted inexpensive, functional earthenware. Colley Shorter took full advantage of this opportunity and in 1920 purchased the adjoining Newport Pottery. The family's three factories made them one of Stoke's biggest earthenware manufacturers. However, their products conformed to the unimaginative, Victorian-influenced designs that still dominated the Potteries. The catalyst that was to revolutionize these designs, and make their competitors re-evaluate theirs, was ware manufactured in the most avant-garde patterns and shapes. The creativity and imagination of a shy, unassuming apprentice would help the factories prosper throughout the Depression: she created a unique style that was to become a household name – *Bizarre by Clarice Cliff.*

Born in 1899, one of the last years of Queen Victoria's reign, Clarice was to disregard the dull artistic heritage of the Victorian era and distinguish herself as a woman of the twentieth century. She was to become a key industrial designer, and also invent the role of what we now call a career woman. None of this could have been predicted in her childhood, when Clarice's world was confined to the family's house in Tunstall, her school and Christ Church, just two streets away. It was there that Harry and Ann Cliff had married and had their two sons and five daughters baptized. The children religiously attended Sunday school, and Christ Church was occasionally the venue of community entertainment including dances. Only Sundays provided any break in the family routine, when after church they would go on trips. The formally landscaped park of Trentham Gardens was just a short train-ride away, but sometimes they ventured into the

Staffordshire countryside. The freedom of the fields was inviting after being confined to Tunstall's narrow streets all week. Clarice and her siblings played as Harry and Ann Cliff strolled leisurely together under a parasol. If they could afford to put together a small picnic, the family would sit on the grass with egg-and-cress sandwiches and refreshing home-made lemonade. Clarice recalled her mother telling them about their courting days when Harry would pick wild honeysuckle from the hedgerows and put it in her hat! Clarice retained fond memories of these childhood jaunts, and they were to inspire her later in life.

Clarice's schooling was certainly not a source of inspiration for her later ceramic achievements as, although she showed an aptitude for drawing, these classes only lasted half-an-hour a week. In order to deliver a daily lunch box to a friend of the family, she went to a different school from her brothers and sisters. Perhaps this made her more independent and free-thinking, as she always appeared happiest in her own company, or with just one special friend. When her sister Dolly made dresses for the Cliff girls to appear in the Christ Church pantomime, Clarice was the only one who did not want to take part, preferring to stay at home. In the school holidays she often visited Johnson Brothers' Alexandra Pottery, in Tunstall, where she watched an aunt – who was a paintress – decorate teapots. Clarice was inquisitive, and the decorators soon learned that she could be kept quiet with a lump of modelling clay!

As the Cliff family grew, they had to move to a larger terraced house on Edwards Street. Clarice now had to share a bedroom with only her younger sister Ethel, who recalled many years later the first stirrings of what was to become *Bizarre*: Clarice painted their chest-of-drawers orange and black. The

house had a small garden in its yard, which Ann Cliff filled with annual plants. Clarice would sometimes bring home a polyanthus as a present for her. Ann Cliff loved flowers but had difficulty remembering their names. Within a few years Clarice would be dreaming up evocative names for her floral designs and the many other patterns that were to pour from her colourful imagination.

When she left school in 1912 Clarice chose to work in a 'potbank', one of the few options for young girls then. She became an apprentice enameller at Lingard Webster, Tunstall. This did not pay well but was reasonably regular and augmented the family income. Clarice was fortunate to find herself doing this, compared to her elder brother who was away fighting in the Great War. In 1915 she moved to Hollinshead & Kirkham, in Tunstall, as a lithographer. Her parents were concerned that her hand-painting skills would suffer, so they paid for her to attend evening classes at Tunstall School of Art. Then, at seventeen, Clarice took the most unusual step of switching apprenticeships. The long daily journey to her new employers, A.J. Wilkinson's at Newport, Burslem, entailed a fifteen-minute tram-ride through Brownhills and Longport, and then a similar length walk. This was a sharp contrast to the two-minute walk to her former job. Little did she realize what a momentous decision this was: her association with A.J. Wilkinson's was to span forty-seven years.

Clarice was one of four hundred employees in a factory with just two designers, both of whom – as was typical then – were men. She worked in the decorating shop and her fellow lithographers remembered her being rather quiet. However, she would chat to them over lunch, which usually consisted of boiled beetroot, lettuce and tomato with bread and butter, and

a cup of tea. Sometimes they would eat this on a nearby bank, overlooking fields where wild flowers were retreating under the piles of waste from the potbanks which lined the Trent & Mersey Canal. The large piles of pottery shards made the area glow like a white desert.

Clarice yearned to be a modeller and sculptress. At the end of the working day when other workers left for the cinema or dance hall, she would often stay behind, modelling figures from clay. Her endeavours and enthusiasm brought her to the attention of the works manager, Austin Walker, and it was through him that Colley Shorter became aware of her talents. Her hard work was rewarded in 1922 when she was given a new apprenticeship as a modeller, earning two guineas a week – a considerable amount then. She began fashioning bowls, vases and fancies under the supervision of designers John Butler and Fred Ridgway. Besides standard tableware they also produced special pieces for shows, and Clarice hand-painted the prestigious *Tibetan* ware for exhibitions. She eagerly wanted to know about every aspect of manufacturing pottery, modelling, hand-painting, firing, and keeping pattern and shape books.

In 1924, the Cliff family home again became somewhat crowded. When her husband died unexpectedly, Clarice's older sister Sarah Ellen, known as Nellie, returned home along with her two-year-old daughter Nancy. Harry Cliff had stopped work through illness, so Nellie's contribution to the upkeep of the house from her work as a forewoman gilder at Alexandra Pottery was fortuitous. When she went out for an evening Clarice was happy to babysit Nancy, who she fondly called 'Nance'. Clarice always had two books a week from Tunstall library and read avidly while Nancy slept, and only went out when she attended evening classes.

In 1926 Colley Shorter and his wife decided to move to a larger house, partly as they had a second daughter Joan in 1920. Their new home, known as the Goodfellow House, had been designed and built by Parker and Unwin for Charles Goodfellow, a friend of Colley's. Amongst his business concerns Goodfellow had since 1895 been part-owner of a small pot-bank, L.A. Birks & Company. His income had enabled the architects to create a home that was custom-designed both outside *and* inside, and worthy of the four-and-a-half-acre site it crowned.

The Goodfellow House was a superb example of the style we now call Arts and Crafts. The interior boasted exposed timber beams and whitewashed plaster walls, fitted cupboards and window seats. The kitchen had fitted dressers in green-tinted wood. In the master bedrooms the windows slid back so that in summer it was possible to sleep with fresh air streaming in. The lounge offered panoramic views of the garden and valley below and the hills beyond on summer days, while a deep inglenook provided a cosy winter retreat. There was a simple, hand-painted Italianate landscape on a long panel above the fire. Colley Shorter had Wilkinson's designer John Butler add knights on horseback to this, and a few years later this image was to be issued as part of Clarice's *Latona* range. Parker and Unwin's basic plan included the layout of the garden, which was ter-raced with hedges of holly and yew, and naturally a very English tennis court.

Colley Shorter was to make many changes to Goodfellow House. The first was that he renamed it Chetwynd House after his previous home in Wolstanton, and this name has remained with the house ever since. Colley saw the new Chetwynd House as the ideal space for his growing collection of European and Oriental fine art and furniture. However, it seems it was never to be a happy home for Annie Shorter, who suffered poor health and became a recluse. With long days at work and numerous sales trips, Colley spent less and less time there.

When he bought Newport Pottery Colley had inherited a stock of old defective ware. In 1927 Clarice had the idea of covering the poorly glazed pieces with triangular patterns in bold colours to make them saleable. Colley gave her a small shop on the Newport site and Gladys Scarlett, a young paintress, to work with her on these in secret. To help Clarice develop her ideas Colley arranged and paid for her to attend the prestigious Royal College of Art in Kensington. Clarice's course included 'modelling the head and figure from life' and 'life drawing'. London's galleries and shops provided a wealth of ideas and inspiration, and gave Clarice a new understanding of the tastes of the twenties' consumer. Looking at the unimaginative, lacklustre pottery stocked by the large

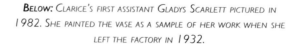

BELOW: CLARICE'S FIRST ASSISTANT GLADYS SCARLETT PICTURED IN 1982. SHE PAINTED THE VASE AS A SAMPLE OF HER WORK WHEN SHE LEFT THE FACTORY IN 1932.

stores, her ideas clarified. When she returned to Burslem the final pieces of the *Bizarre* jigsaw fell into place.

The summer of 1927 disappeared in a mass of work as Clarice designed various sample pieces. The complexity of her unique style was born of a mixture of naivety, endless studying of contemporary art, and a down-to-earth approach to the execution of her work. John Butler had taught her traditional principles, and Colley Shorter instilled in her an awareness of Egyptian and Eastern design, which was fashionable after the discovery of Tutankhamun's tomb. These influences were to result in an outburst of pottery in shapes and designs unlike anything previously made in Stoke-on-Trent.

Clarice and Colley spent many hours discussing ideas. Their close liaison and the fact that Colley was seventeen years older than Clarice prompted whispered speculation amongst the workers about their relationship. It seems this was justified as it later transpired that they secretly went to Paris together at this time, probably to attend the 1925 *Exposition des Arts Decoratifs et Industriels.* The artistic influence of this exhibition was slow to reach the Potteries, but Clarice Cliff was to be the first to capture the Art Deco spirit in her ceramics.

Towards the end of 1927 Clarice had the idea to call her range *Bizarre.* Production was formalized and a special area created adjacent to her studio on the top floor of a building overlooking the Trent & Mersey Canal. Clarice took some young Wilkinson's paintresses to assemble her own team of decorators. Some girls outlined the triangular designs, others enamelled

ABOVE: THE CLASSIC BIZARRE BACKSTAMP INTRODUCED IN 1928.

the colours within the outline, and then each piece had banding applied around the edge or rim on a potter's wheel. They learned to paint the designs tall for candlesticks, wide for bowls, and as a full pattern on larger pieces. At this time Clarice was limited to old traditional ware, and most of these pieces are in the shape number sequence below 300.

The *Bizarre* concept aroused interest from the *Pottery Gazette,* the 'bible' of the industry, which devoted a full article to it in March 1928. The reporter recognized the versatility of ware that was completely hand-painted, and predicted, 'Ornamental pottery with bold and courageous designs treated in vivacious colourings will more and more experience a vogue.' He was proved correct and more press coverage followed in other magazines. Much to the salesmen's amazement, orders rolled in and Clarice needed to employ more decorators. Colley Shorter acknowledged her importance by allowing the simple, painted *Bizarre* mark to be replaced with a large custom backstamp which proclaimed *Hand-painted Bizarre by Clarice Cliff Newport Pottery England.*

Whilst it has long been recognized that Clarice Cliff was an industrial artist who designed for her customers and not always for her own taste, the majority of the hundreds of designs she created were to be inspired by flowers. Although every pottery in Staffordshire had many floral patterns for tableware and fancies, these were by tradition conservative edge motifs, often with elaborate gilding. In the autumn of 1928 Clarice broke away from this style when she conceived what was to be the best-selling pattern throughout her career. *Crocus* consisted of

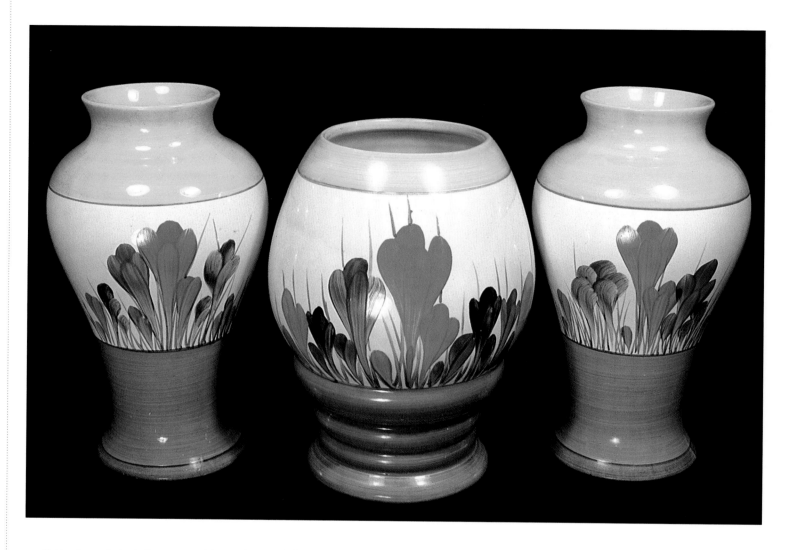

realistically painted flowers with each petal formed from a brushstroke. The dominant orange flowers were teamed with smaller ones in blue and purple, with yellow banding above and brown below, said to denote the sun and earth. Clarice chose a young Wilkinson's paintress, Ethel Barrow, to execute *Crocus*, and the fresh colours made it so popular that Ethel was soon teaching teams of paintresses how to create it. Each decorator applied just one petal colour, and then a 'leafer' finished the pattern before a bander and liner added the brown and yellow banding that acted as a 'frame' for the design. The same

ABOVE: THE ORIGINAL CROCUS DESIGN ON A PAIR OF SHAPE 14 MEI PING VASES AND A 362 VASE, 1928 ONWARDS.

RIGHT: CLARICE'S SIGNATURE DESIGN, CROCUS, FIRST ISSUED IN 1928 AND PRODUCED UNTIL 1963, SEEN ON A SELECTION OF HER SHAPES.

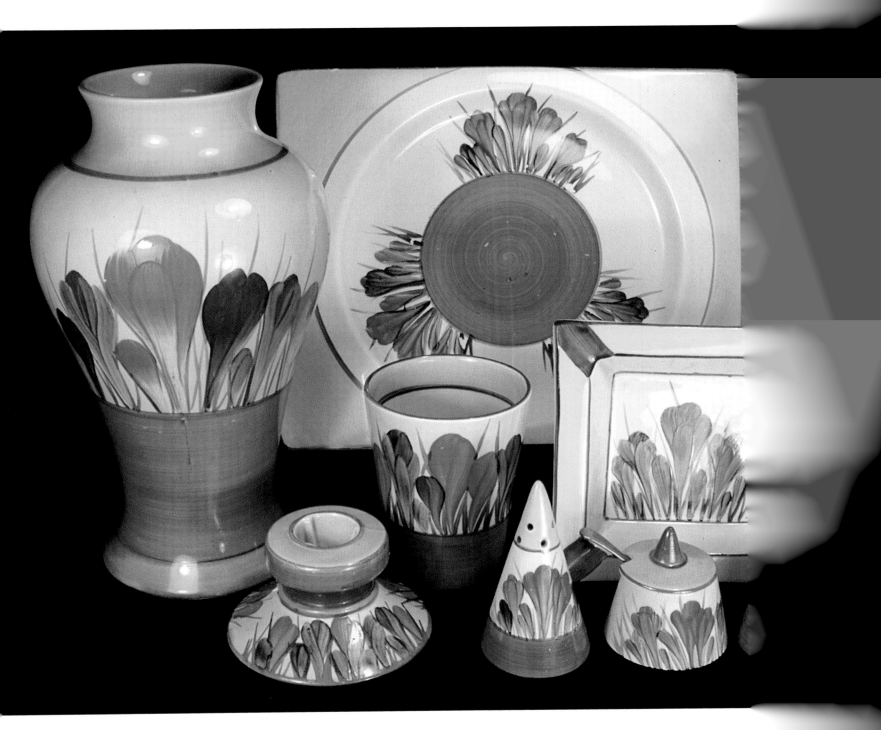

techniques and colours were used for the *Lupin* design, but it lacked the style of *Crocus* and was issued only briefly.

At this time functional ware attracted less tax than 'fancies', so Clarice issued a selection of *Lotus, Athens, Coronet* and *Perth* shape water jugs in her bright *Bizarre* designs. She marketed these as flower jugs, pointing out that the handle made it easier to carry them once they were full of flowers! An older shape that sold well was the 234 *Rose* bowl which had a metal fitment to support the blooms.

Clarice was doing so well that she could afford to buy an Austin Seven for £60, which she promptly named 'Jinny'. She loved driving and was now free to explore the Staffordshire countryside and the Cheshire Plain. Motor cars were still very much a novelty and the smartly dressed young woman behind the wheel soon became instantly recognized.

Throughout 1929 new developments resulted in the factory technicians improving the body of the *Bizarre* earthenware and the glazes applied to it. The standard glaze was refined and called honeyglaze, and this served as a perfect background for the bright *Bizarre* colours. Simultaneously, a new glaze called *Inspiration* was developed. This involved painting oxides of copper on to a 'soft' tile glaze to give a variegated background. On this, designs were painted using copper- and manganese-based pigments. The result was art pottery with a rich, textured purple and aquamarine glaze. Clarice produced many *Inspiration* designs, most of which were floral. The subtle shades enabled her to create *Inspiration Delphinium*, tall flowers in blue, purple and pink, and *Inspiration Lily* with pink lilies. *Inspiration Garden*

was a fuller pattern with a tree in a garden with small flowers.

Because the glazes were so volatile, Clarice established a separate shop to produce *Inspiration*. Marjory Higginson, Edna Becket and Ivy Stringer painted the copper sulphate backgrounds, and the outlining was skilfully done by Ellen Browne. The *Inspiration* range was true 'art pottery', as good as any being made in Staffordshire at the time, and was produced until 1931.

Clarice enhanced the initial success of *Bizarre* by creating her own shapes. The breakthrough came when, inspired by French

ABOVE: INSPIRATION LILY ON AN OCTAGONAL PLATE AND CONICAL CUP AND SAUCER, 1929.

LEFT: INSPIRATION GARDEN ON AN EARLY OVAL FOOTED BOWL, 1929.

LEFT: *The very stylised flowers of Clarice's* Ravel *design, which was popular from 1929 to 1939, on a* Stamford *teapot milk and sugar.*

RIGHT: Blue Daisy *on a* Conical *bowl, 1929.*

BELOW: *A shape 381* Conical *bowl in* Latona Flowerheads.

design journals on *Art Moderne,* she ignored all the design 'rules' her contemporaries slavishly followed. She was influenced by silverware made by the Parisian company Tétard Frères, and the clean geometric shapes of the ceramicist Robert Lallemant, but many of her shapes were completely original. Her first Art Deco range was based upon the startling *Conical* bowl, which had triangular feet. This concept led to the stunning *Conical* teaware with solid handles on the teapot and cups . Designed just for two, Clarice's *Early Morning* sets became fashionable engagement or wedding presents.

Clarice's use of bold colour was radical. She purchased two folios of designs by French artist Edouard Benedictus and these had a profound effect on her attitude to colour. Whereas her *Fantasque Lily* and *Garland* from the spring of 1929 were

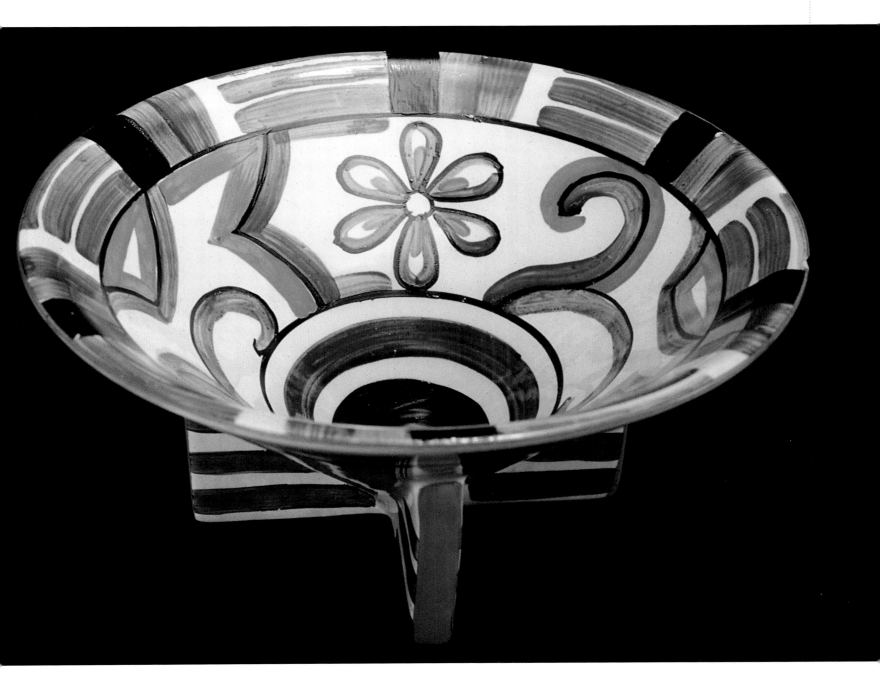

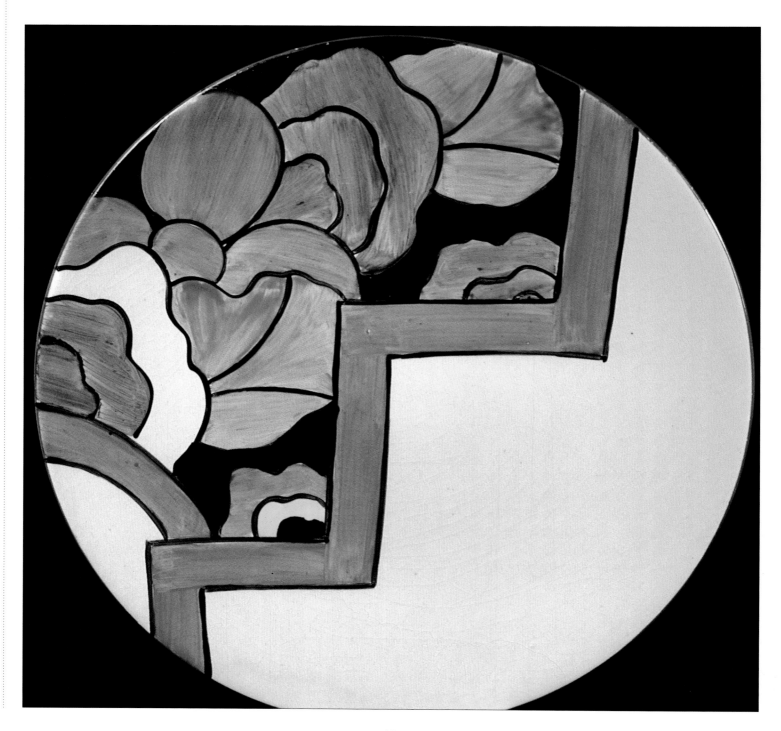

simple florals, by the autumn she had evolved several Art Deco patterns that bore little relation to real flowers. *Geometric Flowers* consisted of circles, semicircles or tiered forms on stems with diamond-shaped leaves, and for *Picasso Flower* she bisected geometric petals with strong angular lines. A floral rarity from this year was *Wax Flower*, half a flower, with geometric leaves and lines. Stylish 'shoulder patterns' for tableware included *Ravel,* a spray of cubist flowers in orange and jade. It sold so well on her futuristic *Odilon* tureens and dinner ware that to satisfy orders a separate *Ravel* shop was established. With her geometric shapes now covered in lavish, all-over colour, *Bizarre* ware caught the public's imagination to the extent that it was to easily survive the Depression that began in October 1929.

A key element in Clarice and Colley's promotional strategy was publicity-seeking, attention-getting demonstrations of hand-painting at major *Bizarre* retailers throughout Britain. Clarice came up with the innovative idea to dress the 'girls' in artists' smocks with floppy bows, and in larger stores she made a 'guest appearance' for a few hours. Many of the *Bizarre* 'girls' had never left Staffordshire before, and seventy years later still recall the

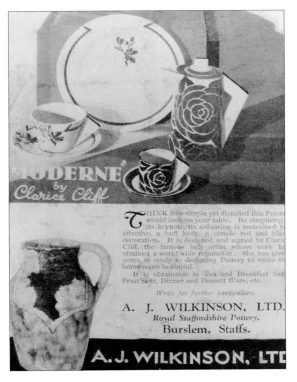

trips. Outliner Eileen Tharme went to Cross Brothers in Cardiff and Spooner's of Plymouth; her sister Phyllis, a bander, went to Rowntree's in Scarborough, and Mary Brown to Lawley's in London. Influenced by how Clarice dressed at the demonstrations, and the clothes they saw in the shops, they were soon regarded as 'better dressed' than their fellow workers. Invariably Clarice and Colley went on these promotions together, as paintress Sadie Maskrey noted: 'When we went to London, Colley Shorter came down a day or two later. Clarice did not stay at the same hotel as us. We didn't know what Clarice was doing, she was a very private person.'

After the excitement of the big cities, Clarice was glad to return to the Staffordshire countryside and spend time with her family at weekends. This invariably meant taking out her favourite niece in 'Jinny'. Many years later Nancy fondly recalled, 'If that car was on the road, I was in it – Saturday and Sunday I lived in it! We covered a radius of thirty miles around the Potteries, and there was hardly any traffic. We went to the Cheshire Plain, Derby, Trentham Gardens and Alton Towers before it became a leisure centre. We had picnics at Tern Hill

ABOVE: AN EARLY ADVERTISEMENT FEATURING MODERNE TABLEWARE AND LATONA RED ROSES CONICAL COFFEEWARE.

LEFT: LATONA DAHLIA ON A 13" WALL PLAQUE, 1929.

for the air displays. "Loop-the-loop" was exciting in those days, sometimes with a brave soul strapped on top of a wing!'

On Monday Clarice would throw herself back into her work. Further experiments led to *Latona,* an innovative matt, snow-white glaze. Initially Clarice issued it with just simple border motifs, but a range of all-over, bold, floral designs soon appeared.

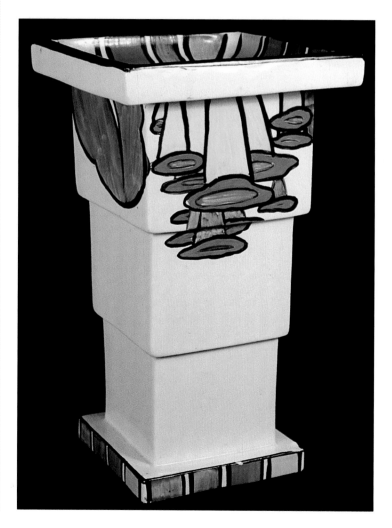

These featured more expensive enamel colours than the standard *Bizarre,* and their style pre-dates the bold florals we see on textiles and ceramics nowadays. Designs such as *Latona Bouquet* were outlined in black before the enamels were applied, whereas *Latona Red Roses* was boldly painted freehand, with flowers in coral red with black leaves. Enameller Cissy Rhodes recalled this was 'difficult to do, you had to put the paint on *really* thickly!' A world away from traditional Staffordshire floral designs, the *Latona* range captured the essence of Art Deco.

In the autumn of 1929 four talented boy designers joined the *Bizarre* 'girls'. Harold Walker, Tom Stringer, John Shaw and Fred Salmon had been trained at the local schools of art but were not allowed to develop fully as designers as their talent for hand-painting was too essential. The *Bizarre* shop now held nearly sixty decorators who were supervised by the 'missus' Lily Slater. They were all extremely skilful with their brushes, which were called 'pencils' at that time. They joined aged fourteen, and by the time they were sixteen they were all experienced decorators. One new paintress, Alice Andrews, was 'tea girl' for a while, 'going out in all weathers to take a kettle to get steaming hot water from a device by the kilns'. Alice, who later became the 'missus', recalled that the *Bizarre* shop was 'cold, dirty and draughty' but she enjoyed the work and made many lifelong friends there.

Colley Shorter never doubted Clarice's ability, though his seasoned salesmen had been sceptical about the saleability of her designs. However, just a year after *Bizarre* was launched, Harrods ordered an exclusive design, *Doré,* which featured a floral motif in a cartouche, and Lawley's of Regent Street had a range of

LEFT: LATONA BOUQUET ON A SHAPE 369A VASE, 1929.

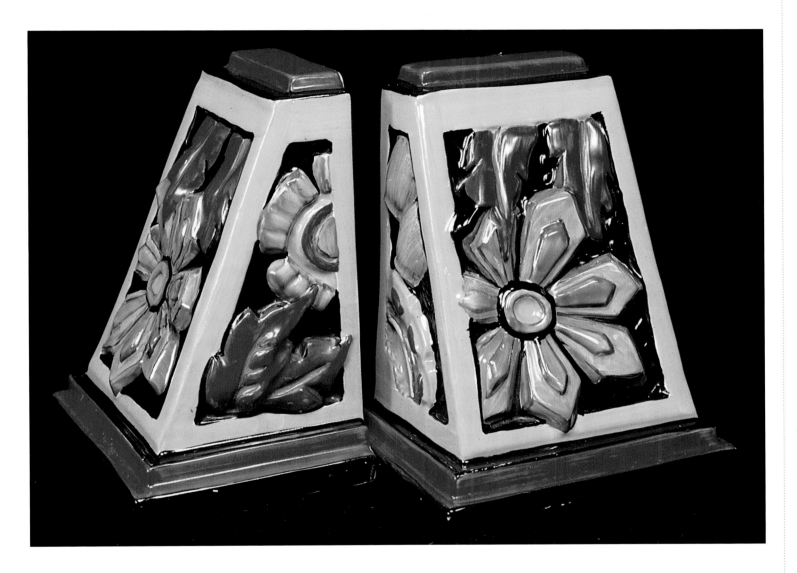

ABOVE: FLOREAT BOOKENDS, SHAPE 406.

exclusive patterns. *Bizarre* was selling not only throughout Great Britain, but was exported to Australia, New Zealand, South Africa, Canada and Brazil. Clarice's main assistant at the works, Hilda Lovatt, started a book of cuttings about *Bizarre* ware from magazines around the world. It grew into a massive volume during the thirties. Clarice Cliff, swept along by her unexpected success, probably never fully appreciated how significant her achievements had become. Every week thousands of pieces of *Bizarre* ware left Newport Pottery bearing her signature. This established her as the most prolific ceramics designer of the thirties, and eventually led to her name being synonymous with British Art Deco ceramics.

THE DESIGNER BLOSSOMS

At the beginning of the new decade Clarice Cliff's energy and enthusiasm gave the impression that she was still in her mid-twenties, even though in January she celebrated her thirty-first birthday. She asserted herself as both a free-thinking designer and a free spirit. She had moved out of the family home and into a flat over a hairdresser's shop at Snow Hill, Hanley. When she was not at work she was busy decorating or furnishing the flat which became her private haven. Apart from Colley Shorter and her sisters, few guests were invited; her niece Nancy usually had tea with her every Tuesday evening. The success of *Bizarre* enabled Clarice to live as she wanted and use her imagination and creativity freely, and she now confidently entered her most prolific period.

It was during 1930 that Clarice Cliff was made Art Director of Newport Pottery. As she was the first woman in the Potteries to achieve this position, the story was reported in the national papers. This in turn led to even more press interest. In a feature in the highly read *Home Chat* magazine the journalist commented, 'When I met Miss Clarice Cliff recently, the brilliant young girl artist and sculptor who was on a visit to London in connection with the *Exhibition of British China and Glass,* I realised how much she alone has done to bring the joy of colour into the homes of other women. I was astonished to find a shy girl, with large grey eyes fringed by long, curling black lashes. She was singularly modest about the delightful artistic creations of her fertile brain.'

Clarice recalled that the idea for *Bizarre* was born when she was at the Royal College of Art. 'It was I think during the dark winter days, when I went shop-gazing in London, that I first thought of my new ideas about pottery. I noticed how very monotonous the designs of pottery and earthenware had become. They were not vivid, or colourful, in the modern sense

ABOVE: PART OF A FEATURE ON CLARICE AND BIZARRE FROM HOME CHAT MAGAZINE IN 1930.

RIGHT: THREE COLOURWAYS OF CROCUS : TOP SUNGLEAM CROCUS, THEN SPRING CROCUS AND THE ORIGINAL CROCUS.

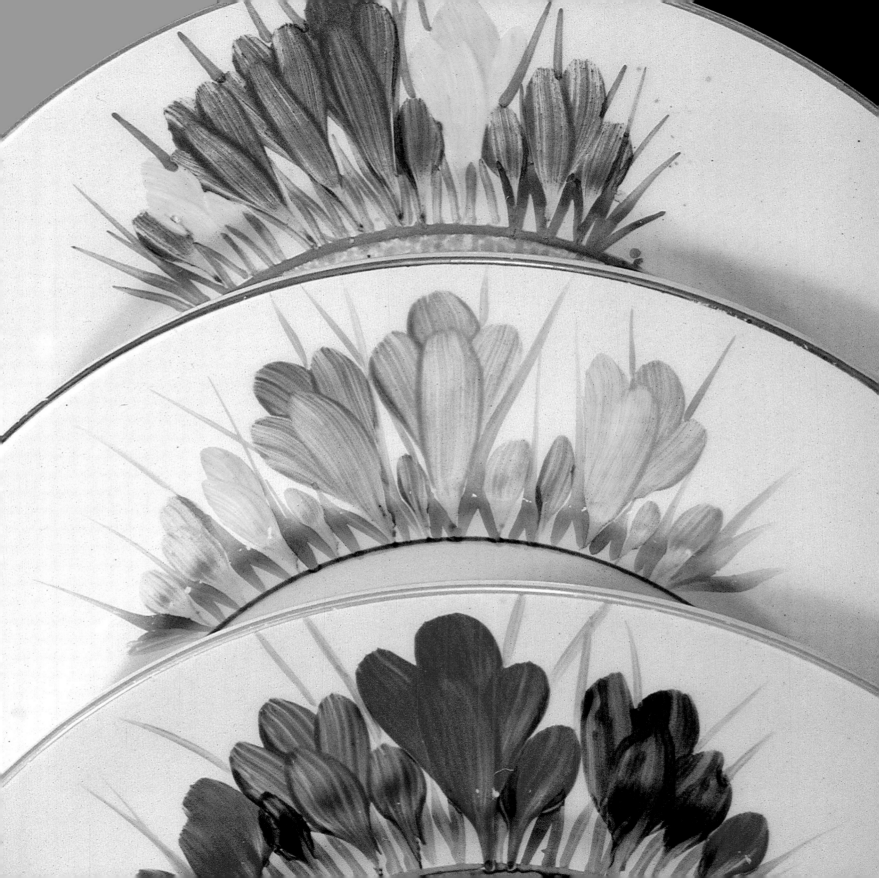

LEFT: APPLIQUÉ BLOSSOM ON A 10" WALL PLAQUE, 1930.

BELOW: AN ORIGINAL DESIGN BY CLARICE CLIFF IN WHICH SHE PORTRAYED A SELECTION OF HER ART DECO SHAPES 'GROWING' FROM A STYLISED PLANT FORM. FROM THE TOP, A STAMFORD TUREEN, A STAMFORD TEAPOT, AN ODILON TUREEN, A CONICAL TEAPOT, AND HER PANSIES AND TULIPS CUT-OUT FLOWERS.

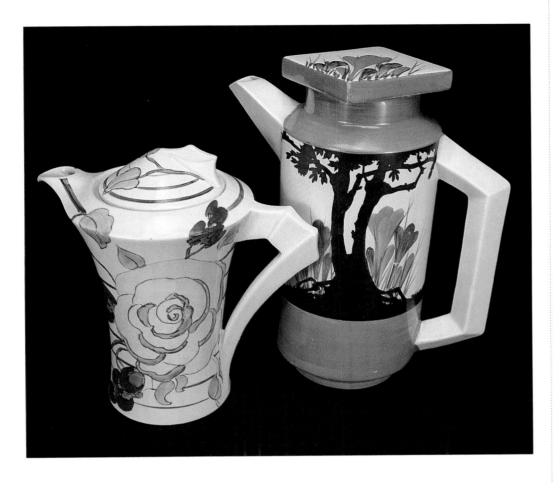

ABOVE: AMBEROSE ON A DAFFODIL SHAPE COFFEE-POT FROM 1932, AND PETER PAN CROCUS ON AN ETON SHAPE COFFEE-POT, 1931.

which one demands today. People had become so accustomed to the designs that they ceased to ask for anything different. I thought, why not design something quite modern as regards colour and form? Something to make our tables brighter, and introduce more vivid colour and modern design into pottery which could be produced at a moderate cost to bring it within the reach of the great masses of the people.'

Colley Shorter's promotional skills were exceptional, and Clarice's very natural qualities when she met the press at trade shows and exhibitions attracted favourable publicity. In the middle of the Depression, bright, colourful pottery, closely linked to

a woman the buyers could identify with, was a strong selling point. Making her Art Director was an astute move. Shorter recognized Clarice's influence both on ceramic design and his profits!

Clarice's landscapes in the *Appliqué* range were some of her most bizarre and yet even these had strong floral elements. The best-selling *Appliqué* designs were the European-inspired *Lucerne* and *Lugano,* but *Palermo* from 1930 featured a climbing plant heavy with flowers with a coastal scene behind. *Appliqué Garden* had stylized flowers by a fence under a vibrant blue or

of a tree in silhouette (sometimes with rabbits underneath) on which the *Crocus* design was hand-painted in miniature. This early, fussy variation was soon discontinued due to low sales, but *Sungleam Crocus* with the flowers in yellow and orange with green banding which appeared the following year was more successful. Meanwhile, Clarice designed *Gayday*, a complementary pattern with similar banding to the original *Crocus* but this time featuring Aster flowers in rust, orange and purple. Each flower was produced by painting a circle of petals, and freehand details were then applied in jade and blue. It was initially painted by Winnie Pound and Ivy Stringer and banded by Elsie Nixon, and sold well for four years.

Decorators who worked continuously on one pattern inevitably found the work tedious so would chatter as they painted, something Clarice disapproved of. She had the idea to put a wireless in the *Bizarre* shop. Immediately production increased as it helped concentration and relieved the repetition as they sang along to popular tunes of the day!

Next, Clarice adapted her *Inspiration* range to create *Clouvre*. This ware had an *Inspiration* ground, with some areas left plain. After the first firing, the design was added in enamels, creating a shiny design on a rich matt ground. Variations included *Clouvre Tulip* with flowers in bright yellow, red and green, *Clouvre Lily* and *Clouvre Butterfly*. The stunning *Marigold* was produced using the same techniques as *Clouvre* but on a less intense underglaze blue ground, and this was only produced briefly.

Clarice created some simple floral patterns for tableware where the design outline was printed, yet still hand-painted in

orange tree. *Appliqué Blossom* was based on a design Clarice produced as *Latona Blossom* slightly earlier and featured passion flowers and clematis on a trellis. *Appliqué Idyll* was untypical, showing a woman in a crinoline in a detailed garden, yet again, much was made of the flowers.

Despite the mass of new designs Clarice issued in 1930, sales of *Crocus* flourished. This resulted in over twenty *Bizarre* 'girls' painting it for several years. *Peter Pan Crocus* utilized an old print

ABOVE: A CLOSE-UP OF CLOUVRE BUTTERFLY ON AN ISIS VASE, 1930.

RIGHT: CLOUVRE TULIP ON AN ISIS VASE (LEFT) AND A SHAPE 384 VASE, 1930.

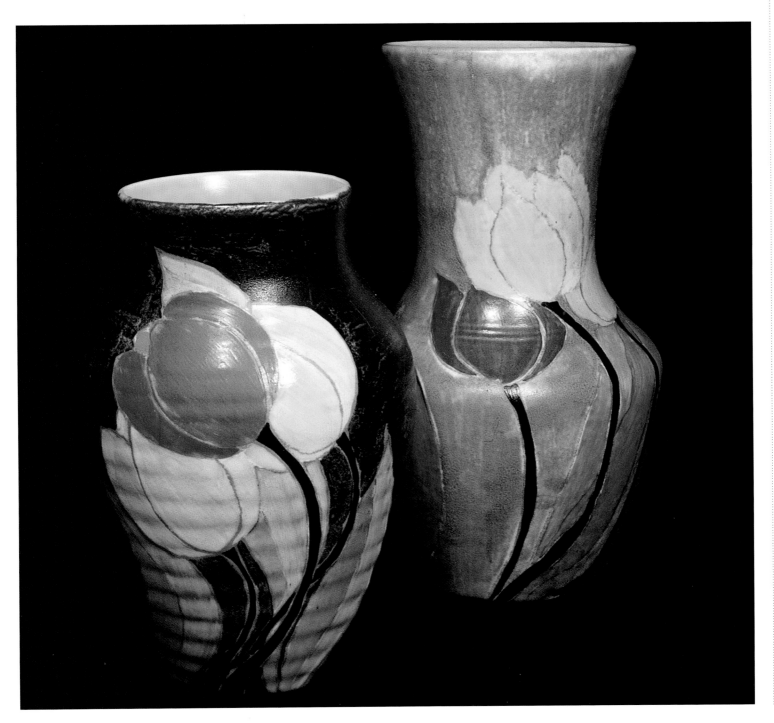

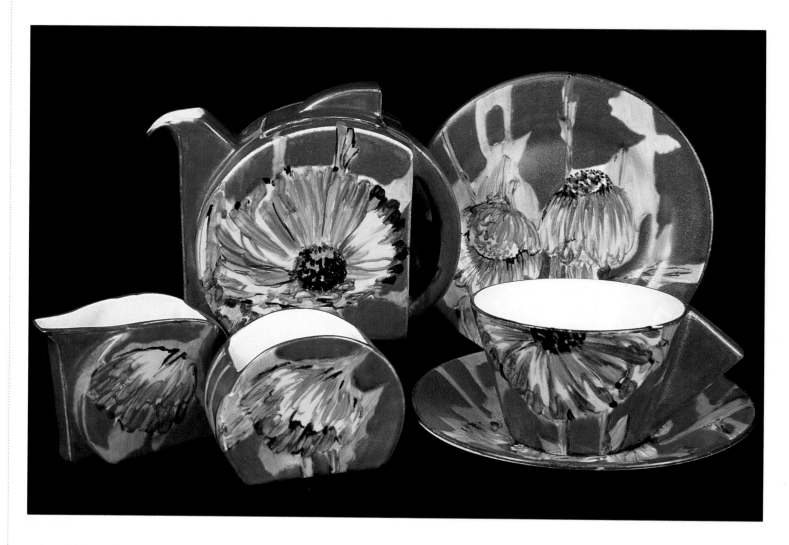

colour. This reduced the cost of decorating and gave a more regular finish. *Solomon's Seal,* in jade, purple and orange with complementary banding, proved popular on her stunning 'D'-shaped *Stamford* teapot introduced in September 1930. *Nemesia* had small flowers in orange, green and yellow with banding in the same shades, and *Fuchsia* was similar but with dominant orange and yellow flowers. The *Chloris* pattern, named after the 'flower goddess' of Greek mythology, was a full-colour print of stylized flowers but with hand-painted banding. However, Clarice disliked the regularity of printed outlines or designs, so despite the extra cost mainly persisted with hand-painted ware throughout the thirties.

LEFT: The Marigold pattern on a unique Stamford Early Morning set, 1930.

BELOW: The rare Pansies and Tulips cut-out flowers, displayed in shape 421 Fern pots, in a publicity photograph taken by Clarice Cliff.

RIGHT: A unique piece, Geometric Garden on a shape 14 vase.

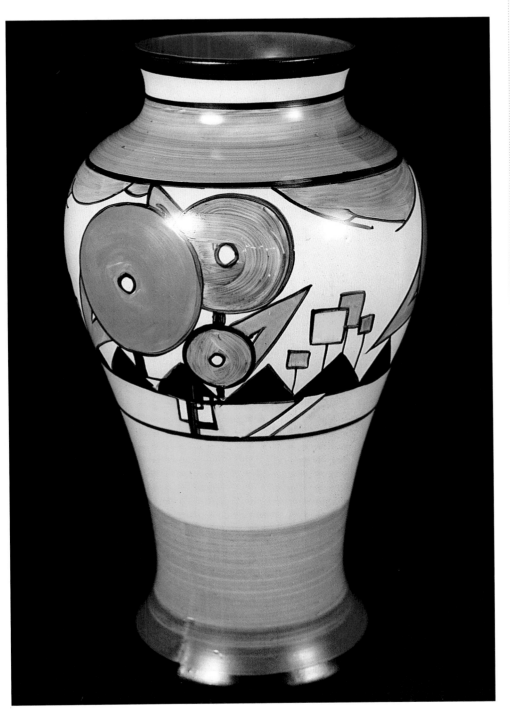

One of Clarice's most innovative floral pieces in 1930 was based on her famous *Age of Jazz* figures which featured flat-sided dancing couples and musicians. She produced cut-out flowers in the same style, with a pug at their base so they could stand in sand in her vases. Clarice said these were 'everlasting flowers' to provide colour in winter when there were no fresh blooms! Two versions were made – *Pansies*, shape 438, and *Tulips*, shape 439 – but being extremely fragile, few have survived.

The production process for *Bizarre* was now streamlined. After designing in water-colour in her studio Clarice selected various shapes from the glost warehouse and took them with her artwork to one of her outliners. Together they would interpret the design on to the shapes. The skill of adapting the original designs to fit on to a range of very different pieces was part of the team effort that made *Bizarre* unique. The outliners would sometimes continue patterns behind teapot handles, make a landscape flow over a vase, or fit a bold flower in *exactly* the right place to achieve the most impact. This method inevitably brought about variation between pieces of exactly the same shape and design, and this variation is what makes hand-painted ware so collectable.

It is easy to overlook the fact that Clarice was at the height of her creative powers when the Depression was at its worst. Many Staffordshire potbanks closed. Clarice had no real competitors: Charlotte Rhead who worked for Burgess & Leigh was made redundant in 1931 and Susie Cooper spent most of 1930 and 1931 with no factory as she fought to establish her first business. By comparison, Clarice Cliff could afford to treat her paintresses to a *Bizarre* outing in the summer of 1930. They

were taken in a charabanc to Llangollen in North Wales. Recalling her own trips as a child to the countryside she organized this just for her 'girls'. They walked and chatted, played games, and Clarice and Colley provided sandwiches, slab-cake and lemonade. To this day, some of them still cherish photographs of the outing.

Back at the factory, Clarice again innovated by adding new fancies to her range. Facemasks were a very popular addition as wall decorations in the twenties and thirties. Clarice had issued *Chahar*, an Egyptian-inspired one in 1929, and Ron Birks – a young apprentice – produced a cubist one for her which she called *Grotesque*. By 1931 she modelled more realistic facemasks; *Marlene* was based on film star Marlene Dietrich. However, the mask with the most commercial appeal was *Flora*, which featured a young girl's face with her hair garlanded with flowers. Small and large sizes were produced and they were painted in strong or soft colours to suit the customer's decor. Confusingly for today's collectors, *Flora* was also the name of a hand-painted shoulder pattern.

With a floral theme continuing to be uppermost in her mind, Clarice used the shape of a flower as her inspiration for a new range of tea and coffeeware – *Daffodil*. The curved bodies flared gracefully and the solid coffee cup handles were corrugated like the flowers. The range was complete, having its own cups, milk jug and sugar bowl. From late 1931 onwards it was also made in a special pale-pink body covered in a clear glaze which Clarice called *Damask Rose*. The decoration was just small, freehand floral or fruit motifs. Clarice probably became aware of the real-life Damask Rose, first cultivated in Paris in the

RIGHT: GARDENIA RED ON A STAMFORD TRIO, A SHAPE 362 VASE, AND A PLATE, 1931.

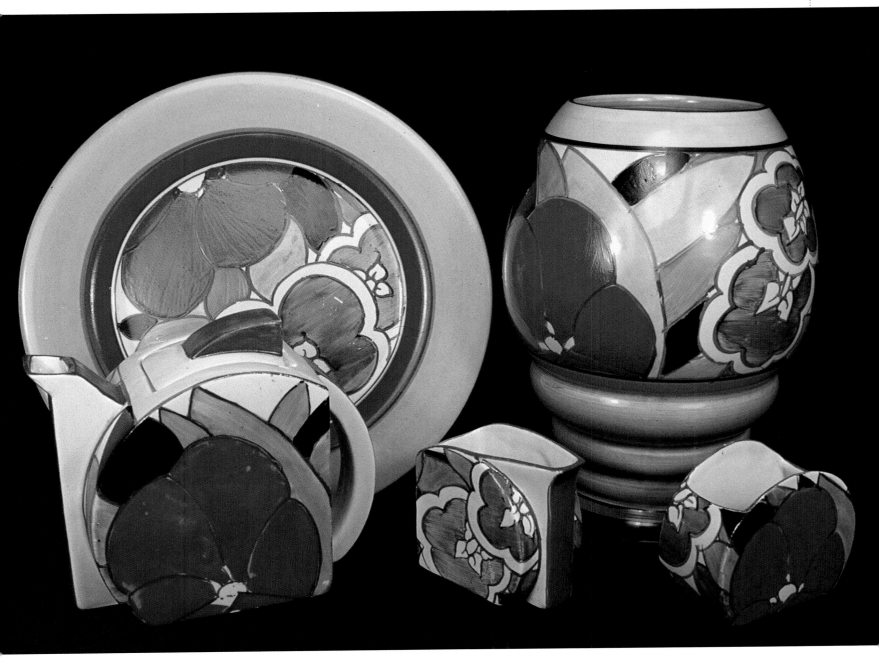

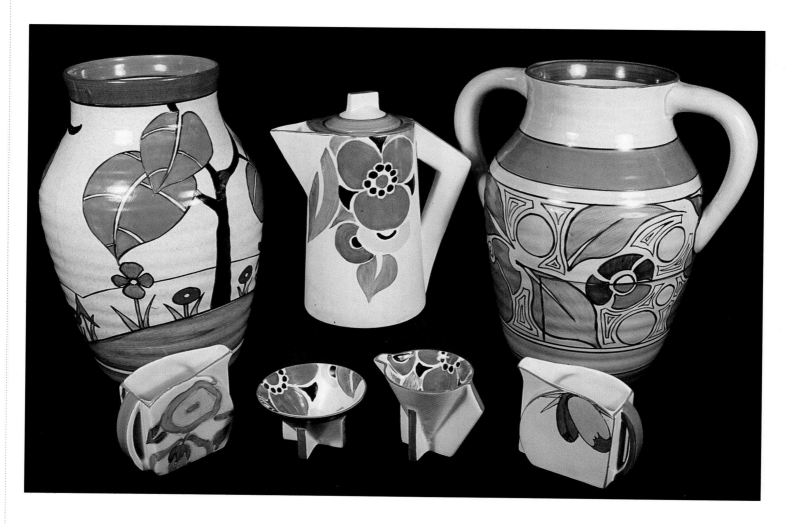

nineteenth century for the manufacture of the attar of roses fragrance, because of her love of heavy scents. The *Daffodil* shape range was extended to include a vase and bowl with stylish handles, shapes 450 and 475, which proved good sellers. Most stunning, however, were some vases Clarice created specifically to hold just a few flowers. These *Flower Tube* vases, shapes 464 and 465, comprised one or two tall, thin tubes, on

a flat 'S'-shaped fin. As their intricate design suggests, they were expensive to produce and cost eighteen shillings and sixpence each, the price of a complete Early Morning set!

Clarice's most successful 1931 floral was *Gardenia*. Large salver-shaped flowers in orange or coral red were surrounded by black and green leaves. By this time Clarice had hundreds of shapes on which customers could order designs, and *Gardenia*

LEFT: LEAF TREE ON AN ISIS VASE *(1933),* LATONA GENTIAN ON A CONICAL COFFEE, MILK AND CREAM SET *(1930),* PROPELLER ON A DOUBLE-HANDLED LOTUS JUG *(1931),* STAMFORD MILK JUG IN GREEN CHINTZ *(1932)* AND STAMFORD MILK JUG IN FLORA *(1930).*

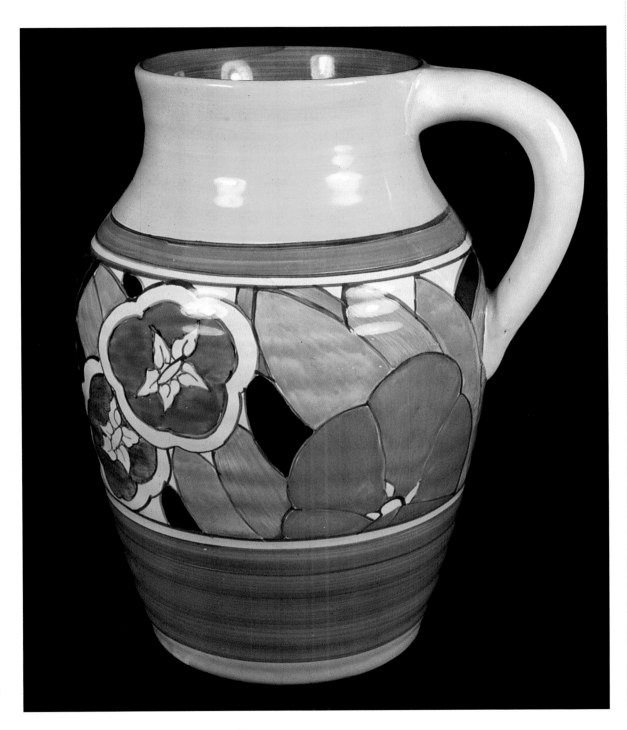

RIGHT: GARDENIA ORANGE ON A LOTUS JUG, *1931. THE SHAPE OF THE JUG WAS DESIGNED IN* 1919 *AS PART OF A WASH SET. CLARICE USED IT AS A FLOWER VASE FROM* 1927.

is found on teasets, vases, bowls and fancies. One particularly strong floral issued in 1931 was *Propeller*. Its flowers were so formalized that they looked like propellers and were different colours either side of the lines that bisected them.

Although 1931 was another tough year for the pottery industry, Clarice's high profile meant she was frequently interviewed about *Bizarre* in women's magazines and newspapers. When one journalist asked where she got her ideas, she replied, 'they were borrowed from meadow flowers, from gems, from bits of bright enamel as were produced by old Italian craftsmen … Everything with a touch of orange in it I had noticed seemed to take people's fancy, while jade green was another winning colour.' One magazine, *Women's Journal,* held a co-promotion, offering their readers an exclusive floral tableware pattern. *Women's Life* gave away twenty-four sets of *Chloris* on a tradi-

tional shape in a competition to 'think of the five people you would like to invite to tea if you won this service'.

Clarice started to add strong floral elements to some of her landscapes. *Fantasque Red Roofs* featured a cottage, but on the reverse were giant orange flowers. The *Poplar* design had large flowers in the foreground, with a cottage and the two poplar trees it was named after in the distance. *Idyll* was moved from the *Appliqué* range to *Fantasque* and changed from strong colours to softer ones.

By the end of 1931 Clarice had designed over 150 numbered shapes for *Bizarre* ware. Collectors wishing to date pieces will find it useful to know that 340–402 first appeared approximately between mid-1928 and 1929, and 403–499 between 1930 and 1931. Most of these shapes continued in production for some time after introduction, and not all were issued chronologically, so shape numbers are not a totally reliable way to classify her output. As well as numbered shapes Clarice issued many named ones, which easily took her shape output over the two hundred mark in just three years. Her productivity is amazing when one realizes that simultaneously she had issued a mass of new designs and a variety of innovative glazes, and appeared regularly in stores.

Next, Clarice issued a new range that was to launch a style, *My Garden,* which became a best-seller later in the thirties. *Marguerite* featured flowers embossed on the body of ware, or modelled as handles on cups and milk jugs. The simple daisies were painted in a choice of colours and the body of the ware could be left plain or given a *Café-au-lait* finish. This was the

Left: Marguerite ware teapot and milk jug in green Cafe-au-Lait, 1932.

Right: Nasturtium on a Daffodil coffee-pot, cup and saucer, 1932 onwards.

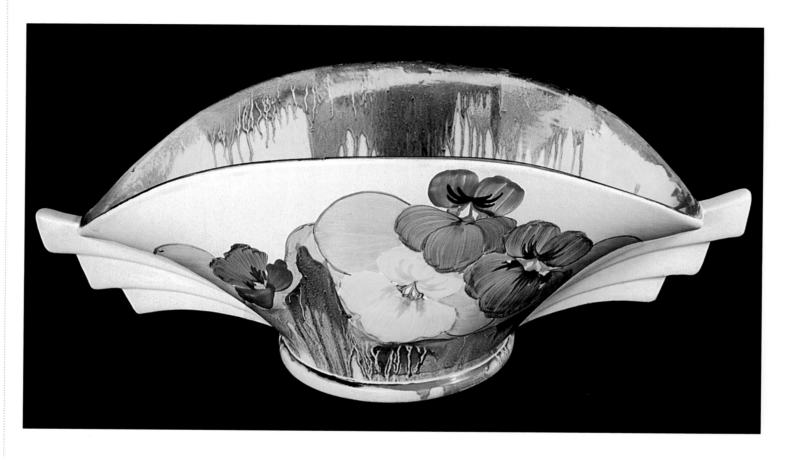

name Clarice gave to a mottled surface colouring produced with a special 'stippling' brush.

Colley Shorter intensified *Bizarre* promotions in 1932 by using large backdrop displays and securing the services of personalities of the day to endorse the ware: from the actress Marion Lorne, to band leader Jack Hilton, to national hero Sir Malcolm Campbell. However, when Clarice returned from these events, she reverted to a casual lifestyle at weekends, as Nancy recalled. 'We would just walk and look at the beautiful flowers. She was very fond of flowers, and in spring we went to the wonderful bluebell wood at Moddershall near Barlaston. As we walked she encouraged me to be inquisitive by asking me to count the number of flowers or different birds we could see, and listen for the cuckoo.'

ABOVE: DELECIA PANSIES *ON A* DAFFODIL *bowl shape 450.*

RIGHT: DELECIA POPPY *ON A SHAPE 358 VASE, 1932, AN* ANEMONE ISIS *VASE, 1937, AND A* DELECIA PANSIES *ON A* VIKING BOAT *flower holder, 1932.*

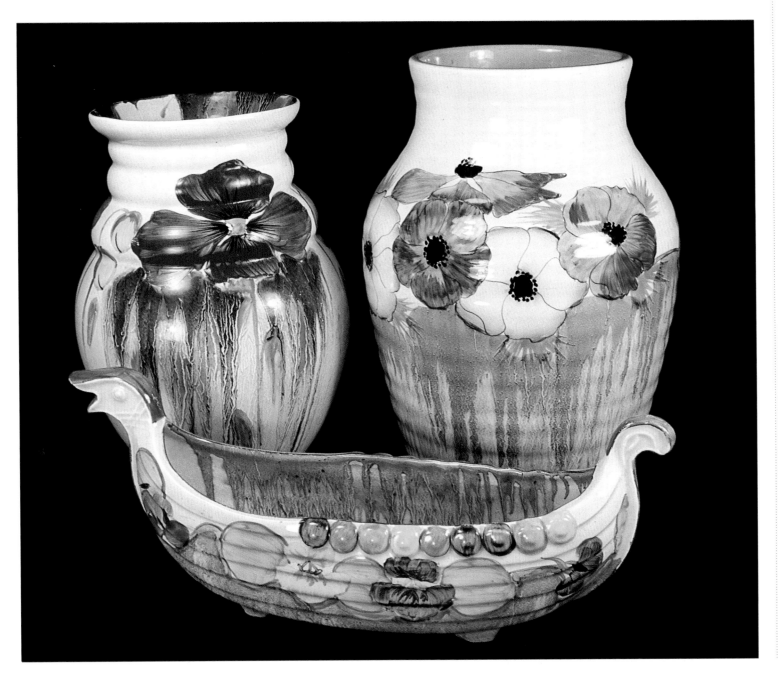

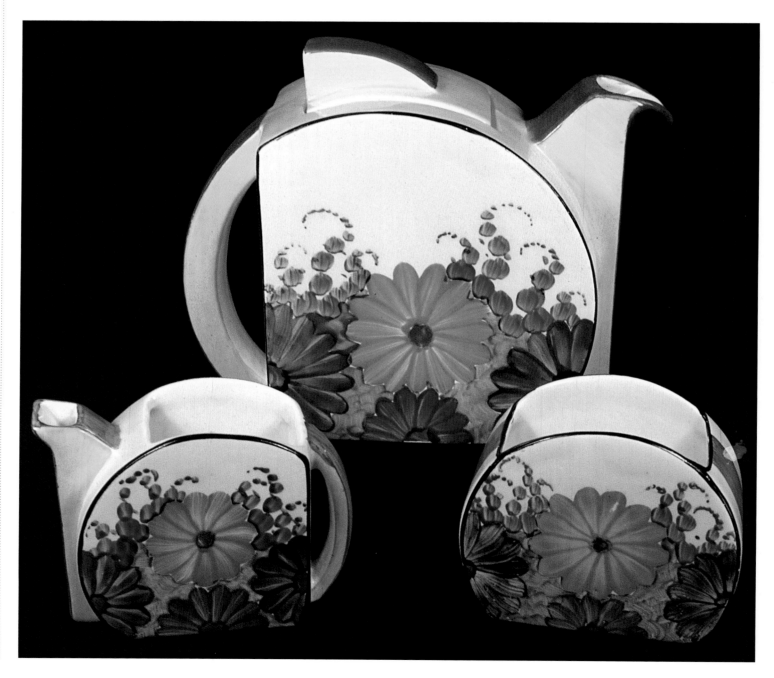

Perhaps inspired by her weekend walks, Clarice's new 1932 designs included yet more floral patterns. *Nasturtium* and *Canterbury Bells* used the *Café-au-lait* technique extensively. *Nasturtium* had bright yellow, red and orange flowers painted freehand, with green and black detail and brown *Café-au-lait*. *Canterbury Bells* had bluebell flowers teamed with primroses all painted freehand as a partial motif with the remainder of the ware covered with brown or yellow *Café-au-lait* stippling.

Delecia was the name coined in 1929 by Clarice to describe ware decorated with 'runnings'. By thinning enamel colours in turps it could be creatively run down the ware. Clarice revived it in 1932 and combined it with floral patterns, creating *Delecia Nasturtium*. For *Delecia Pansies* Clarice used a great deal of artistic licence as the flowers were actually nasturtiums in bright pink, yellow and blue. *Delecia Poppy* featured vibrant red flowers, again with colourful runnings. The range was popular with customers for over three years.

Clarice's *Chintz* design was rather strangely named as it was based on water lily leaves and buds as an 'all-over' pattern. The first colourway had dark and mid-blue, green and pink painted in such a 'jazzy' fashion that the shapes looked like fried eggs! *Chintz Orange* – a colourway in black, red, orange and yellow followed, and hit an even more visually strident note.

In the early thirties all workers in potbanks had just one week's unpaid holiday each year, known as the 'potter's holiday'. All factories gave their workers the same week, generally in June or July. Some *Bizarre* 'girls' were able to afford trips away from the Potteries in these weeks. Eileen and Phyllis Tharme went with Winnie Pound, who recollected, 'We went to Colwyn Bay for a week but could not afford board. They provided milk and potatoes, but we had to buy our own meat and vegetables which they cooked, and the cruet was sixpence! We had Phyllis, who was older, as our chaperone.' Rene Dale, one of the newer paintresses who joined in 1931, preferred Rhyl, and others would go on motorbike jaunts in the Staffordshire hills with their boyfriends. In contrast, Clarice often stayed in Stoke during the potter's holiday, but when Nellie Cliff took her daughter Nancy to the south coast resort of Bournemouth, Clarice drove all the way down to join them. Nancy remembered, 'Clarice sat on the beach with us and her arms and face swelled up from sitting in the sun – she was poorly!'

Apart from these short periods of relaxation away from the Potteries, Clarice worked intensely hard. Next, she developed more ware with modelled flowers. Her impressive *Bouquet* wall medallion (shape 553) was a round plaque of heavily modelled flowers emphasized with cut-out areas. The enamellers applied both bright and soft colours which gave the shape a versatility that made it so fashionable in small and large sizes that production continued for most of the thirties.

Clarice now took the meaning of modelling to new extremes. *Patina* was ware given a surface encrustation by 'splattering' it with liquid clay, which gave it a sandpaper-type finish. Freehand patterns executed on this were mainly landscapes but some florals are known. The *Le Bon Dieu* range was evolved in 1932 by basing the shapes on tree boles, but it was not successful. Whilst these experimental pieces show the avant-garde side of Clarice, it was patterns such as *Crocus* and *Gayday* that were most lucrative. Clarice issued a new design based on

LEFT: GAYDAY ON A STAMFORD SHAPE TRIO, 1930.

Gayday featuring the same flowers in green, blue and yellow, and called it *Sungay*.

Clarice's appearances at trade shows continued and at one in London she and Colley met Edward, Prince of Wales. They were formally introduced, and he asked which part of Stoke they came from. Colley replied 'Burslem', and the Prince said, 'Oh, I've been there'. He then spoke with Clarice who told him, 'You can always recognize someone from the Potteries, as if there is any crockery around, we have a habit of picking up a piece and looking underneath it' The Prince asked, 'Why is that?' Clarice replied, 'Because we want to know who has made it!'

Exports of *Bizarre* ware were significant. Eric Grindley, then an office junior, recalls that 25 per cent of production went overseas. Colley Shorter was the key to this success, having established strong, personal customer links from as early as 1907, and he continued with these trips in the thirties. They took many tiring weeks but he always rose to the challenge as if he were an explorer, sometimes having to travel by flying boat.

The paintresses observed that he always returned with a case full of orders, flamboyantly dressed in a tropical white suit and a stetson!

At the *British Industries Fair* in February 1933 Clarice launched *Windbells*. This featured a swirling psychedelic sky, and a formalized tree with blue blossoms, alongside tall delphinium-style flowers. Outliner Harold Walker worked on it for many months, and it sold extremely well, particularly on Clarice's new *Bon Jour* range which had round flat-sided teapots, and oval flat-sided coffee pots. *Cowslip* was a busy design combining outlined flowers with *Café-au-lait* in a choice of brown, blue, yellow or green colourways and on the *Bon Jour* teasets even the saucers were fully decorated. Some further designs combining florals with *Delecia* runnings were issued: *Lydiat* had stylized flowers in orange and pink above amber runnings, and the same pattern featuring green and yellow flowers was called *Jonquil*.

Clarice's own design work was to be delayed in 1933 when she spent time developing the *Artists in Industry* project. This was initiated by the Gorell Committee report on Art and Education after comments made by the Prince of Wales. Clarice was chosen to supervise the production on earthenware of designs by famous artists of the day. This massive task resulted in the *British Industrial Art in Relation to the Home* exhibition, at Dorland Hall. Prestigious artists such as Duncan Grant, Vanessa Bell, Laura Knight and Barbara Hepworth were involved and many produced floral designs. These are now less collectable than Clarice Cliff's work, which reinforces the opinion of some collectors that her work is literally 'art on a plate'.

LEFT: A CROCUS ADVERTISEMENT FROM 1933.

RIGHT: COWSLIP BLUE ON A BON JOUR EARLY MORNING SET, 1933

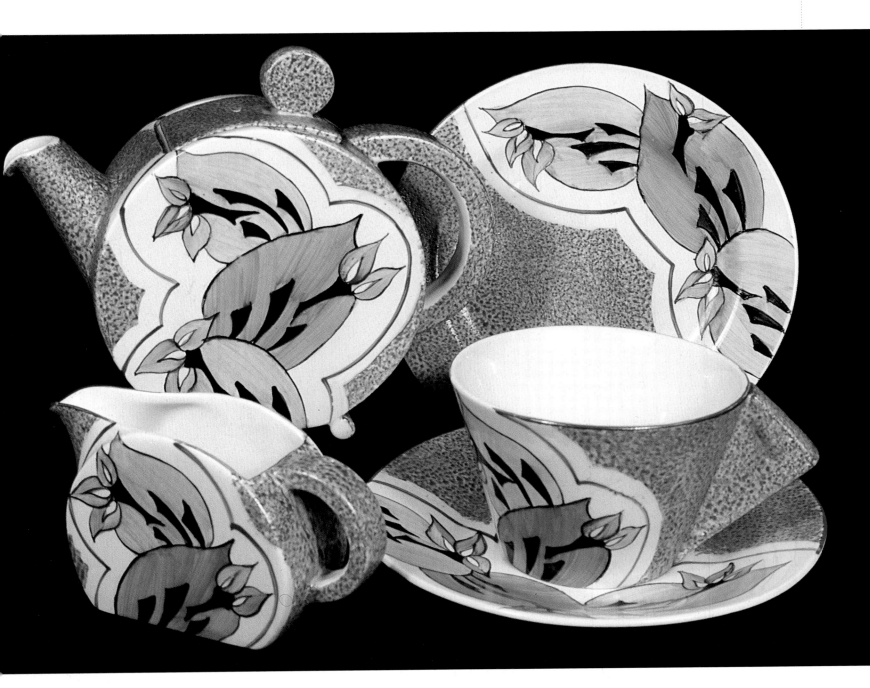

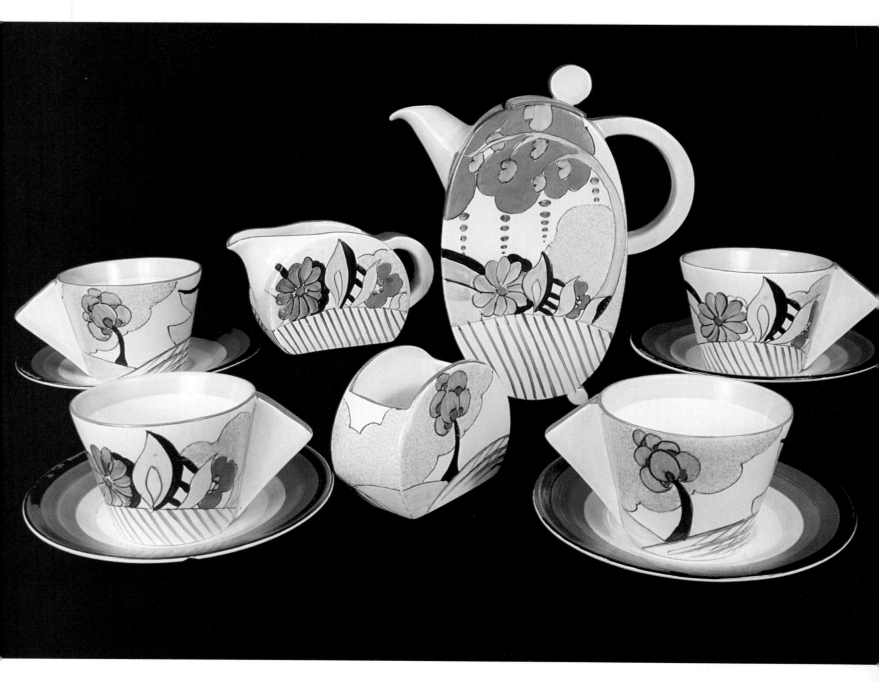

LEFT: DEVON *ON A* BON JOUR
COFFEE SET, 1933.

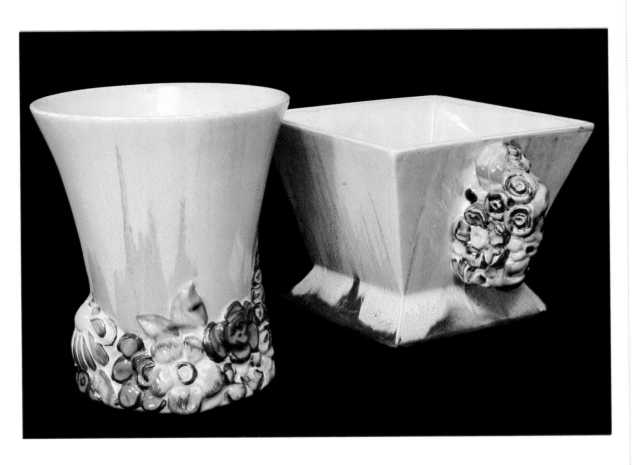

RIGHT: MY GARDEN SUNRISE
ON A 675 VASE AND A
670 BOWL.

Clarice's involvement with these artists was, however, to affect her style. This resulted in the artistic spontaneity of *Bizarre* and *Fantasque* being gradually replaced with more sophisticated, subtle designs and soon her landscapes were to feature mainly garden-inspired scenes. Rather than featuring mountains or full vistas, they were more intimate. Early ones such as *Moonlight* were produced in almost radioactive colour combinations: blue and pink trees with pendant azure flowers, and giant flowers underneath in yellow and dusky pink. *Moonlight* was also produced in vivid alternative colourways called *Devon* and *Cornwall*.

In the spring of 1934 Clarice developed the *Marguerite* ware concept and created *My Garden*. This range of vases and jugs had their bases and handles modelled as flowers. The smooth body of the ware was decorated in simple runnings whilst the flowers could be executed in any number of bright colours, achieving very individual effects. The original range, *My Garden Sunrise* with the body in tan and yellow, was launched at the *Daily Mail Ideal Home Exhibition* in July 1934. Just before it opened, Clarice went out with her assistant Hilda Lovatt and bought masses of fresh flowers which they arranged in the

LEFT: A 1934 ADVERTISING LEAFLET FOR THE ORIGINAL MY GARDEN RANGE, WHICH WAS LAUNCHED WITH TWENTY DIFFERENT SHAPES.

RIGHT: FLOWER JUGS, SHAPE 677 IN MY GARDEN PINK AND MY GARDEN AZURE SHAPE 672, AND A MY GARDEN FLAME VASE 669.

vases. It was an instant success and in the following years more shapes and colour variations were produced. *My Garden Verdant* had a green shaded body, *My Garden Azure* was blue, and *My Garden Night* was matt black. It was an economical line to produce as even new apprentices found it easy to apply the colours on to the shaped flowers.

Some of Clarice's original paintresses left in 1934, so had to be replaced by new 'girls'. The older ones looked after them, and Lily Slater, the 'missus', taught them how to grind colour and use their brushes until they were capable of producing finished ware. One recruit was Edna Cheetham, who recalled the evolution of *Rhodanthe* which she spent many months producing.

It featured etched brushstrokes where the paintresses blended colours. To aid those doing the etching, Rene Dale would first sketch guidelines in Indian ink for the flowers and stem, which disappeared when the pieces were fired. The bold flowers in orange, brown and yellow were then etched producing realistically shaded petals. Clarice's ever-growing library of books had provided the source for *Rhodanthe,* a flower native to Australia, *Helipterum manglesii.*

Rhodanthe was immediately successful and stockists who wanted exclusive designs were offered the same pattern in different colourways: *Viscaria* with blue and green flowers, *Aurea* in green and yellow, and a later pink-dominated colourway was

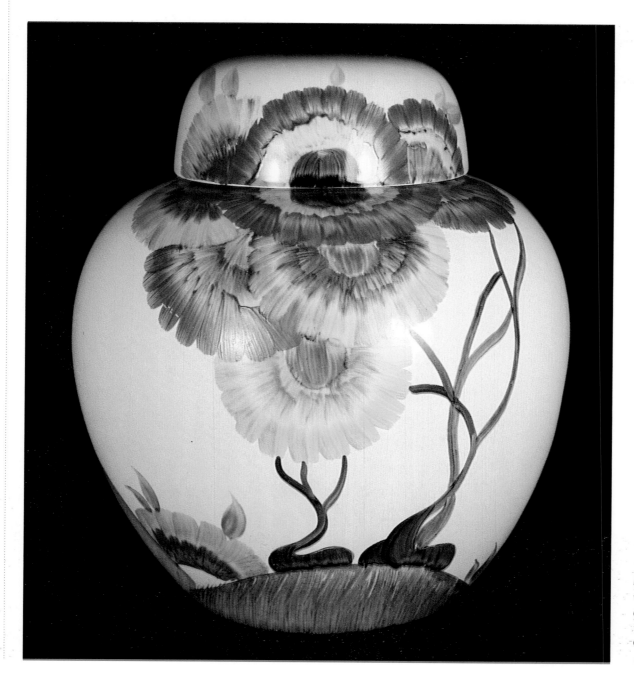

LEFT: RHODANTHE *ON A SHAPE* 132 *GINGER JAR, 1934.*

RIGHT: VISCARIA *ON A* 13" *WALL PLAQUE, A LATER EXAMPLE OF THE* CONICAL *BOWL,* 1934, *AND AN* AUREA CONICAL *SUGAR DREDGER,* 1934.

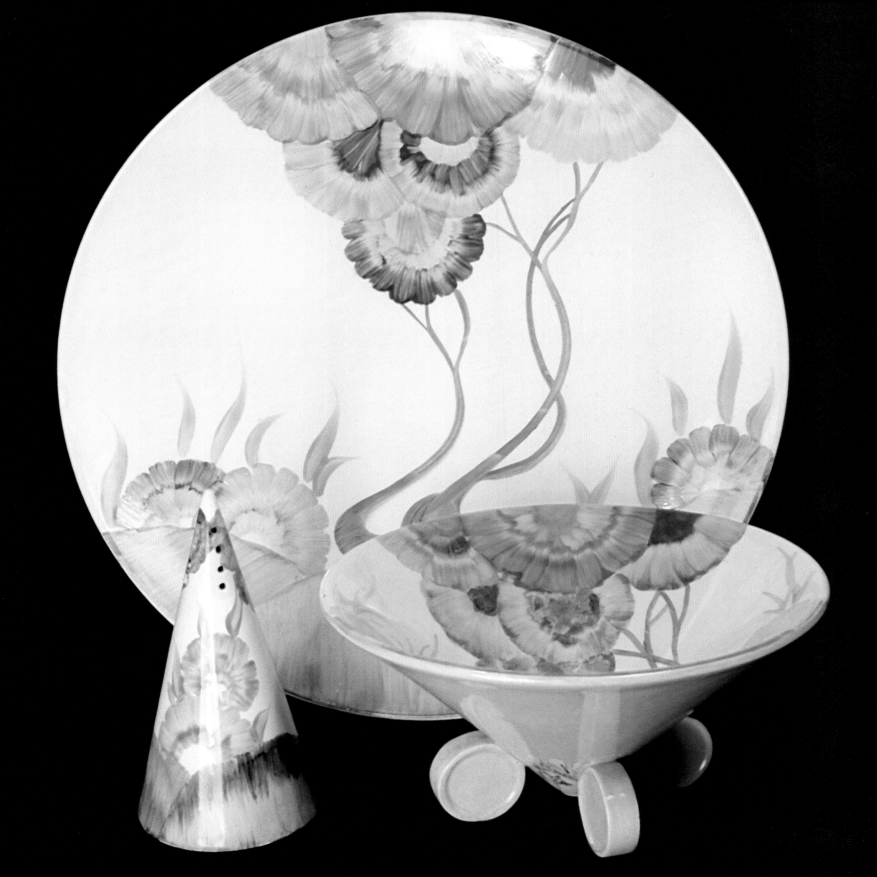

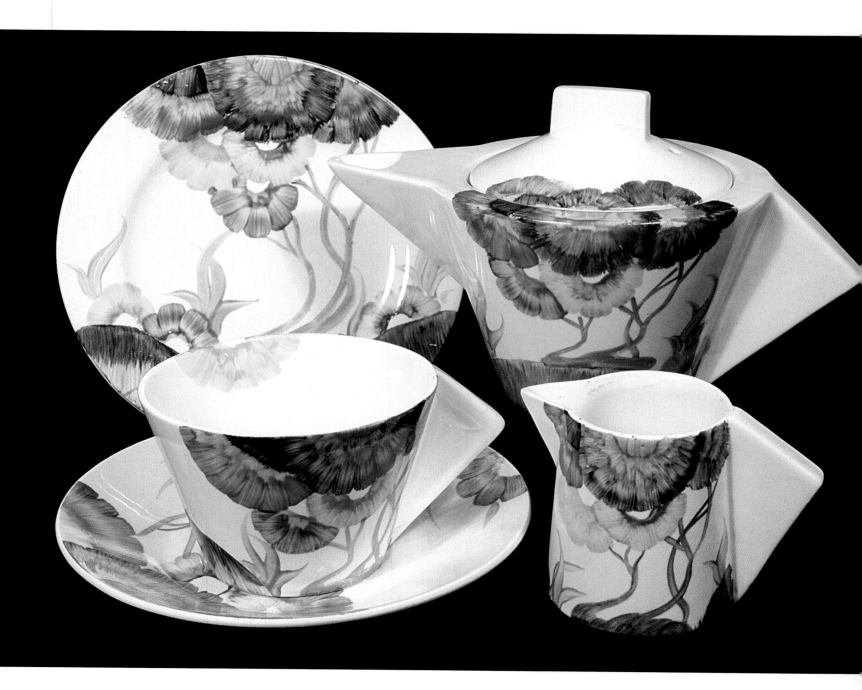

LEFT: AUREA ON AN EARLY MORNING CONICAL *TEASET,* 1934.

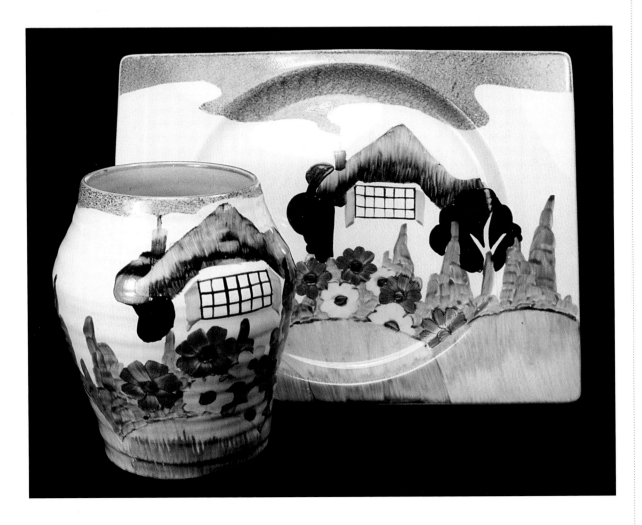

RIGHT: TRALLEE ON A SHAPE 539 VASE AND A BIARRITZ PLATE, 1935.

called *Pink Pearls*. In 1935, Clarice simplified *Rhodanthe* exclusively for Hardware Bristol, wholesalers in the south-west of England. The flowers were formed into a central motif on tableware, and the colourways were *Honeydew* in green and yellow, and *Sundew* in green and pink. This pattern kept enamellers Doris Johnson and Jessie McKenzie, and banders Nora Dabbs and Mollie Browne, busy for many months.

Clarice's country garden theme came to fruition at this time, with two scenes which combined freehand and etched painting. *Sandon* was a simple scene of a single tree with yellow and orange delphinium-type flowers, and the same design with blue and pink flowers was called *Fragrance*. By removing the tree and adding a thatched cottage, Clarice produced *Trallee!*

By 1935 *Crocus* had been in production for seven years in

53

nearly every shape imaginable. To enhance its sales potential, Clarice created various colourways. Perhaps the most stunning was *Blue Crocus,* which had chic yellow and blue banding, but sadly for today's collectors this beautiful colourway was produced only briefly so is hard to find. Even rarer is *Purple Crocus,* produced around the same time.

Occasionally Clarice would encourage the 'girls' to help her produce designs. Marjory Higginson had the idea to make small flowers using a fingertip in translucent banding to make a circle of petals, then fine-painted dots completed the flower. This was first done with *Honiton* and also used for *May Blossom.* Marjory had joined Clarice in 1929 as a bander, and recalled that working for her enabled the 'girls' to enjoy a good social life. To treat herself she would spend ninepence on the best seats at the opera when it came to the Theatre Royal in Hanley. Annie Beresford, who mainly outlined landscape designs, preferred spending her money at the cinema to see Rudolph Valentino at the Coliseum or Palace at Burslem.

Since 1928 Clarice had driven her car 'Jinny' thousands of miles but now it needed replacing. In July 1935 she was able to afford a brand-new Austin Seven Pearl Cabriolet. Whereas her first car had cost £60, this cabriolet version with customized grey paintwork was £197. Aware now that 'Jinny' was a rather working-class Staffordshire name, Clarice chose the more sophisticated 'Jenny' for the new model. Naturally, Nancy was amongst the first passengers, and one location they were to visit that year was Chetwynd House.

Clarice had spent a Saturday morning at the factory with Nancy 'in tow' and had to take some samples to show Colley.

LEFT: BIZARRE 'GIRLS' DOROTHY HIGGINSON, MOLLIE BROWN AND EDNA CHEETHAM ENJOYING A BREAK AWAY FROM THE BIZARRE SHOP IN 1935.

As they arrived at the house Nancy was suitably impressed, but going inside she found it to be 'cold, not very nice, gloomy, dark, dismal'. Annie Shorter was an invalid by this time which is perhaps why Clarice was able to visit. Many years later the eldest daughter Margaret told how her mother 'would not have that woman's name mentioned in the house'. If, by chance, Clarice peeked out of the living-room window that day, little would she have dreamt that just a few years later the huge garden would be hers.

Colley Shorter involved Clarice in yet another prestigious project in November 1935 – a dinner ball at the Dorchester in Park Lane, London. It was to celebrate King George V's Silver Jubilee, and was held in aid of the Paddington Green Children's Hospital. The event was under the patronage of the Duke and Duchess of York, who a year later became King George VI and Queen Elizabeth. Clarice and Colley were on the committee and contributed prizes of *Trieste* shape *Early Morning* sets. These were in the evocatively named *Capri* design, which showed a further move towards floral and garden themes in Clarice's work. Stylized flowers and bushes were covered with fine concentric lines, and the pattern proved fairly popular. The *Trieste* shape was based on a triangle theme, which was extended not just to the teapot but also to the plate and saucers, which were three-sided!

Clarice supervised the display of the 'decorated tables' for the ball. These featured her outlandish *Biarritz* oblong plates in a simple green and black pattern, and for table decorations her *Age of Jazz* figures. Her work appeared in the programme alongside royal jewellers Mappin & Webb, Savile Row tailors Jarvis & Hamilton, and court jewellers Carrington & Co. of Regent Street. Clarice and Colley spent the evening with six

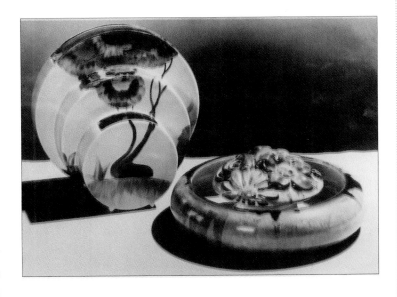

ABOVE: A SHAPE 674 TRIPLE BON JOUR VASE IN RHODANTHE, AND A FLOWER CENTRE SHAPE 729 FROM THE MY GARDEN RANGE IN A 1935 ADVERTISING PHOTOGRAPH.

ambassadors, three commissioners, the Romanian chargé d'affaires, Mrs Stanley Baldwin and many members of the aristocracy! The event gave them the chance to appear in public as a couple, and they waltzed to 'When I Grow too Old to Dream', played by Ambrose and his Band, after dining on Saumon Fumé d'Ecosse and Delices de Sole. The magic of that evening was to be in stark contrast to events that followed a few months later.

By January 1936 Great Britain was in a sombre mood after the death of King George V. This, and the following abdication crisis, may have contributed to a change in public taste that Clarice soon echoed in her ware. During that year the *Bizarre by Clarice Cliff* trademark was replaced with just *Clarice Cliff*. Perhaps Colley felt she had achieved sufficient world-wide

recognition to use just her name? Simultaneously, many of the Art Deco shapes were deleted from the salesmen's catalogue, and more muted designs were created. Her floral designs became more finely painted with a lot of shaded brushwork. Typical of this time was *Anemone,* although in the old *Bizarre* spirit this was also done briefly with *Delecia* runnings. One of the last really vibrant designs produced was *Chalet,* which mixed a garden-inspired scene with Clarice's cottage motif. The flowers were made from individual spots of enamel colours, the whole design being completed with *Café-au-lait* stippling.

Clarice and Colley continued to export a great deal of pottery and mounted major promotional events to stimulate sales. The effort put into these was shown by a display at Scott's Hotel in Melbourne, Australia, in 1936. Thirty tables and masses of wall displays were piled high with *Biarritz* and *Odilon* dinnerware, *Bon Jour* and *Lynton* tea and coffee sets, *Flora* wallmasks, *Conical* and *Bon Jour* sugar dredgers, lampbases and *My Garden* ware. One design that may have been featured at this exhibition is *Braidwood,* which is mainly found in Australia. *Bizarre* ware was also featured in the mid-thirties at a show at Usher's Hotel, Sydney, and an exhibition staged by Foyes of Perth. In New Zealand *Bizarre* was stocked by a number of stores, Ballantynes in Christchurch, large stores in Palmerston North, and Smith & Caughey in Auckland.

In Britain in 1936 a journalist for the *London Evening News* spent some time with Clarice as she was finalizing her stand at a trade show. The article by Penelope Brim, 'New Ways with Flowers', appeared on 17 September. What she wrote gives an insight into Clarice's love of arranging flowers in her pottery.

Flower decoration and modern table appointments have brought about a change in artistic expression in our homes. Now has come another change. This morning I watched Clarice Cliff, the well-known woman pottery designer, arrange bronze chrysanthemums in a dull lichen-green, square shape trough. She spread them in a spiral garland across it, with blooms drooping lightly over its brim. A green platter with a hint of coffee brown in it had beech leaf tinted chrysanthemums arranged like a long-stemmed cross, tapering off to a single bloom over one side. A squat, pyramid shape vase in pale water green with golden stars as decoration, had one white dahlia set formally in it. The flower was so large that it completely covered the opening of the receptacle. Another very shallow platter-shaped vase also had a single bloom as decoration, a magenta coloured dahlia. This contrasted with the black rim of the platter which had oatmeal and warm yellowy-pink in its composition. A motor car finished in a soft, matt glaze, had platinum on the usual chrome parts and held pale-pink and mauve cosmos, and trails of virginia creeper.

This 'car' was Clarice's sleek ceramic version of Colley Shorter's SS sports car!

Clarice still modelled fancies but tableware was the most important part of the factory's output in the later thirties. There was a penchant for wall pockets with modelled fronts and flat backs to hold water to display a few fresh or dried flowers. Clarice issued many of these, including a version of *Flora,* and

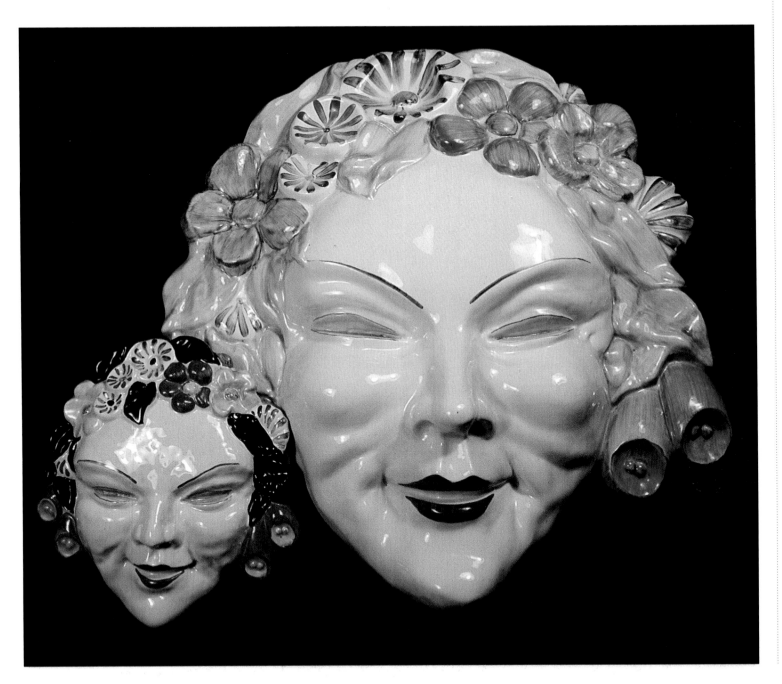

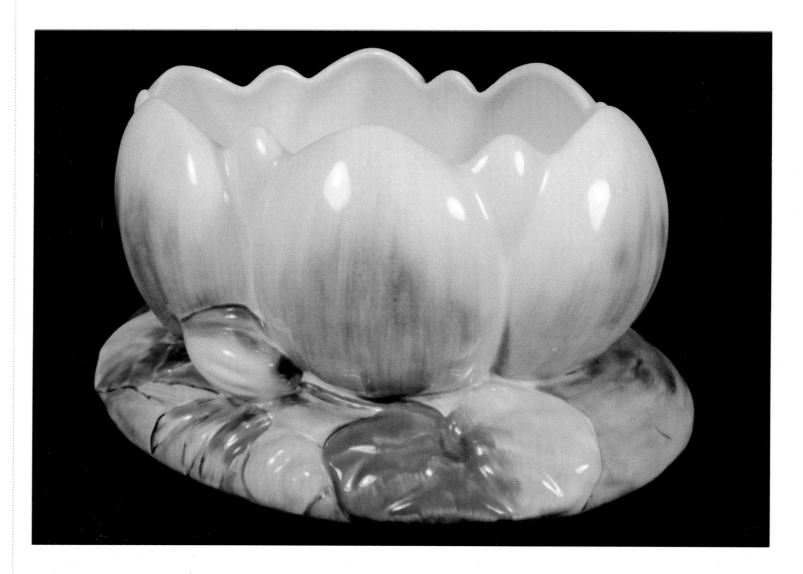

ABOVE: A WATER LILY SHAPE 976 BOWL, 1938 TO 1956.

the *Convolvulus* wall pocket was popular before and after the war. A large range of *Water Lily* fancies featured vases, bowls and teaware modelled as the flower. The best-selling piece was the shape 973 *Water Lily* bulb bowl which was produced in various colourways, many painted by Mary Moses, whose 'M' mark is sometimes on the base. Eric Grindley, by now a factory manager, remembers thousands were sold for the home market to Carter's Seeds, and even more were exported to New Zealand and Australia. By 1938 the sequence of shape numbers reached 999 and the final shapes before the war were numbered from 001 onwards, but many of these were only produced as tradeshow samples.

Clarice had persisted with hand-painting even when it became less and less commercially viable and, when a paintress left, maintained the skills by taking on new 'girls', including May Booth in 1937, and as late as 1939 she employed Marianne Holcroft and Ray Booth. But the war forced her to disband her treasured team, who left to work on munitions or the land. Just a few remained to fill export orders for tableware, the ever-green *Crocus,* or *Celtic Harvest* which was her last major range before the war. With its embossed flowers and corn sheaves it sold well overseas until as late as 1941, and in North America was patriotically named *England.*

Fate played into Clarice's hands when, shortly after the war had started, Colley's wife Annie died. He decided to ask Clarice to marry him, but, concerned about how this would look so soon after his wife's death, he sought the endorsement of his friends. At The Leopard, his club in Burslem, a friend told him, 'It's about time you married that girl!' Colley then felt the need to get the consent of Clarice's mother! Much to the surprise of Ann Cliff, they arrived unexpectedly at her home. Despite her illness Ann managed to understand that although he was 58 years old, ever the Victorian gentleman, Colley Shorter was asking for permission to marry her 41-year-old daughter!

On 21 December 1940 Clarice and Colley were married. In deference to both their families only a few close friends were told and it was then kept secret for a year. Recognizing the value of her name, which had been stamped on millions of pieces of *Bizarre,* Colley agreed that she should be known as Clarice Cliff-Shorter. It was a marriage in keeping with their 'bizarre affair' of the thirties. One of the first employees to find out was sales-man Ewart Oakes, who Clarice informed by letter on 10 December 1941. 'I have been trying to sneak ten minutes to write to you for the last several days, and this is my first chance. I have a bit of news for you which may not come as much of a surprise – Colley and I are married – this at the moment is not generally known, but I know that you can be discreet.'

Clarice's life changed direction totally. Rather than spend the war years alone in a flat, with no real work, the unfortunate death of Colley's wife meant she could exchange the dirt and smoke of the Potteries for the fresh air of a Staffordshire hillside home. Clarice Cliff was now the mistress of Chetwynd House.

CLARICE CLIFF'S HOUSE AND GARDEN

When they designed the Goodfellow House, Barry Unwin and Raymond Parker were already noted for their individuality, being vegetarians who wore suits of homespun Isle of Man tweeds. Luckily, they had an imaginative client in Charles Frederick Goodfellow, a local potter, miller and miller's merchant who supplied clay bodies to the pottery trade. In 1899 Goodfellow commissioned them to build a house on an open hilltop site to the west of Stoke, which was originally part of the estate of the Duke of Sutherland.

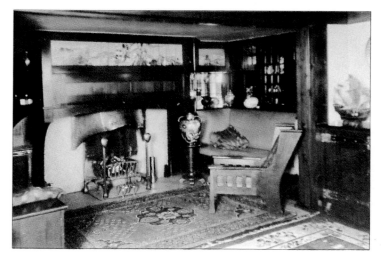

ABOVE: THE INGLENOOK AT CHETWYND HOUSE. THE CHAIR AND CABINET ON THE RIGHT WERE ALSO DESIGNED BY PARKER AND UNWIN. THE DOUBLE-HANDLED VASE IS BY GOUDA.

RIGHT: HYDRANGEA AT CHETWYND HOUSE.

BELOW: THE ENTRANCE HALL AT CHETWYND HOUSE WITH A BUILT-IN ARTS AND CRAFTS DRESSER DESIGNED BY PARKER AND UNWIN. THE PHOTOGRAPH DATES FROM THE FORTIES, NOTE THE CLARICE CLIFF AND SHORTER CERAMICS.

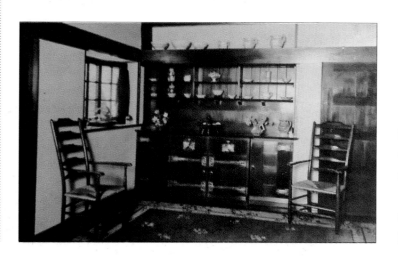

Parker and Unwin's design was highly innovative and they were also given the opportunity to incorporate elaborate features, design much of its furniture and fixtures, and plan the large, terraced garden.

The country lane that led to the Goodfellow House, as it was first called, was lined with hedges which were broken only by a pair of gates in a north-facing brick wall which opened on

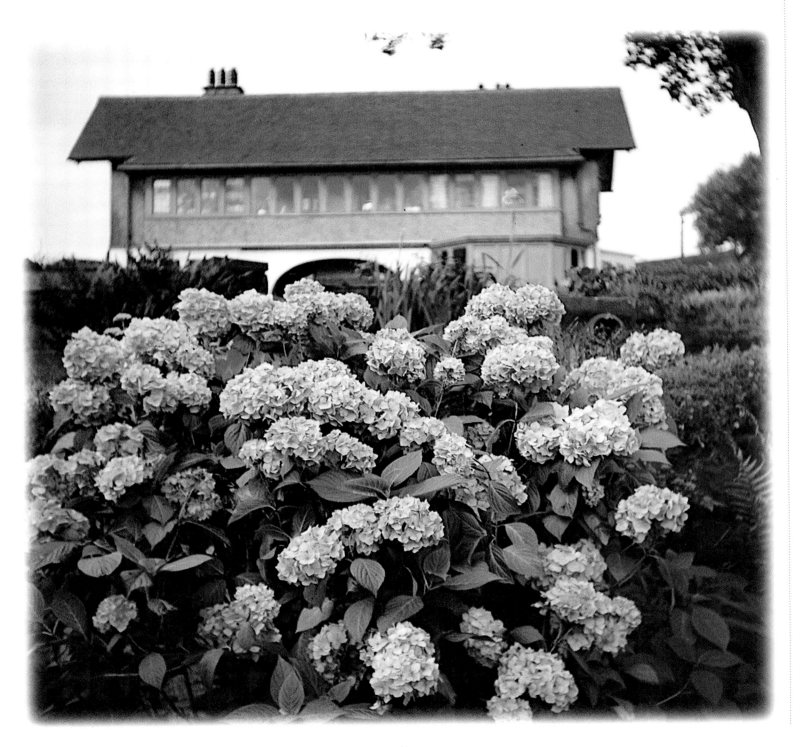

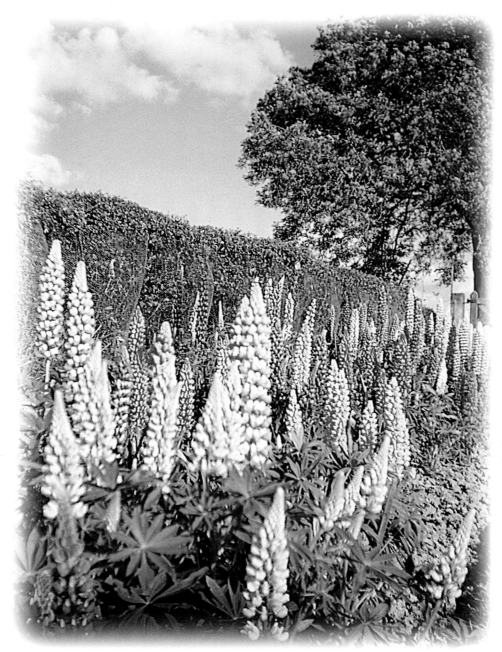

LEFT: COLLEY SHORTER'S PRIZED LUPINS REARING UP IN FRONT OF A YEW HEDGE IN A PHOTOGRAPH TAKEN BY CLARICE CLIFF IN SPRING, 1952.

ABOVE: GENTIANS ON THE CHETWYND HOUSE ROCKERY, PHOTOGRAPHED BY CLARICE CLIFF IN 1952.

to a cobbled stable courtyard. From this there was direct access on one side to the stables and wash house, with other out-buildings on the other side. A small door gave access to the house and from there the kitchen and scullery, which over-looked the yard. This side of the house was mainly occupied by the servants.

The formal entrance was on the south-west side. An elabo-rate Arts and Crafts timbered porch led to an impressive oak door with a leaded glass window which depicted a rural land-scape. This door opened on to a large room, originally an open

BELOW: PART OF THE CHETWYND HOUSE ROSE GARDEN.

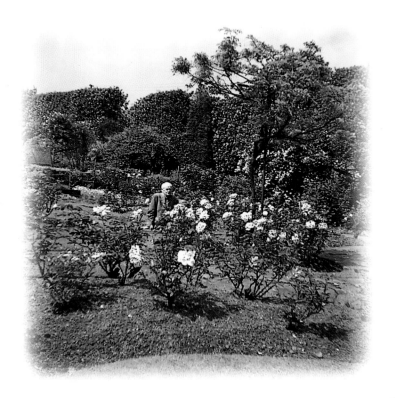

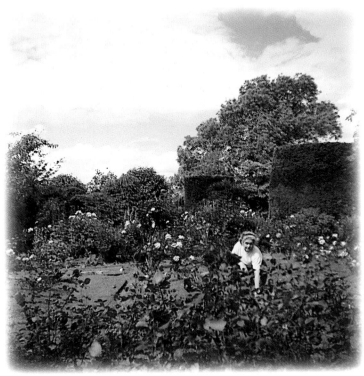

ABOVE: CLARICE PHOTOGRAPHED BY COLLEY IN THE ROSE GARDEN.

courtyard but redesigned in the Forties as a second living-room. This, in turn, led to a formal hall and dining-room on the one side, and on the other, a large living-room. A feature inglenook and an informal dining area were at opposite ends, and an angled recess was designed to allow space for a piano. An enclosed verandah leading off the hall-cum-dining-room area had a southerly aspect and so enjoyed the benefit of the sun throughout the day. The dining area gave way to a large bay with a built-in window seat overlooking the garden and the valley below. The land itself was fertile with the gardens descending in

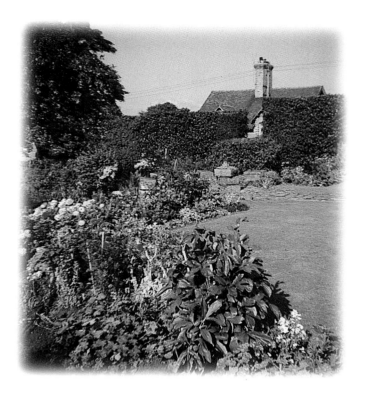

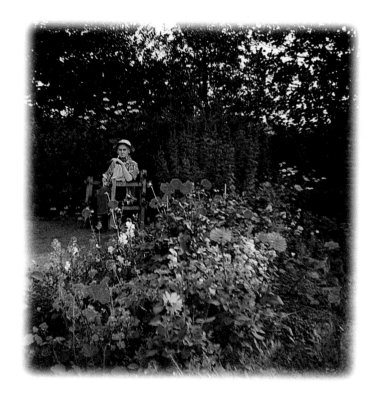

ABOVE: A CORNER OF THE GARDEN IN HIGH SUMMER.

ABOVE: COLLEY SHORTER RELAXING AMONGST CLARICE'S COLOURFUL SUMMER FLOWERS.

gentle terraces to the south and south-east.

A unique feature of the house was a central courtyard, entirely enclosed on four sides, but open to the sky. Parker and Unwin later wrote that it 'was planned to have the roof sloping down to it on all sides to make sure that light should always flood it and that it should bring brightness and cheeriness and airiness right into the midst of the house'. They had put sash windows into the four walls surrounding the courtyard so that, when open, 'the corridors running around this court are then converted into open cloisters, and in so sheltered a position

they can be left open for all but the very coldest weather'.

Shortly after they completed the house, Parker and Unwin published *The Art of Building a Home,* a collection of essays which elaborated on their principles for good design in housing. They were particularly concerned with smaller dwellings. They believed in reducing the number of rooms in a home so that the essential ones were larger. Parker wrote, 'if your big room is to be comfortable it *must* have recesses'. He also felt strongly that furniture should be designed for the house. 'Most things to look right and happy in their places must be designed

RIGHT: A WISTERIA TRAINED AS A TREE ON ONE OF THE LOWER TERRACES.

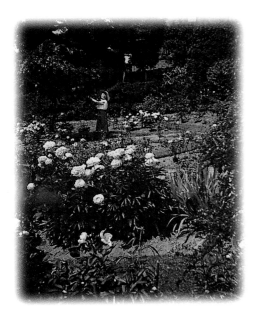

ABOVE: CLARICE REACHING INTO A TREE IN THE ROSE GARDEN, IN A POSE REMINISCENT OF THE CRINOLINE LADY IN HER THIRTIES IDYLL DESIGN.

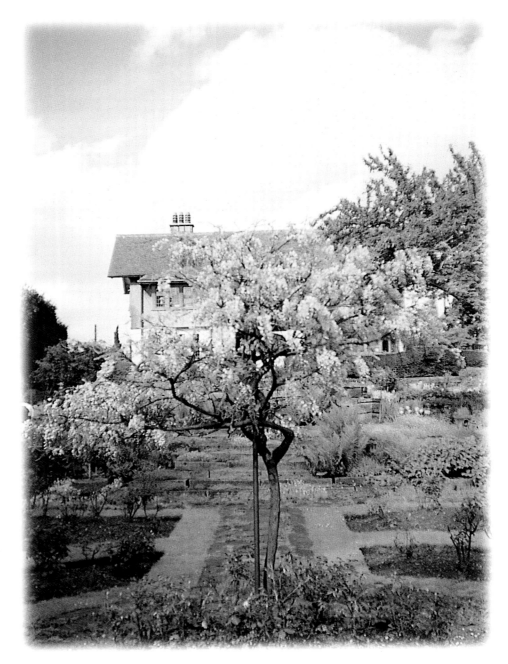

ABOVE: A BORDER OF VIBRANT DELPHINIUMS AND ROSES CAPTURE CLARICE'S STRONG THIRTIES COLOURS.

League. Their work became influential, and impressed American architect and furniture designer Gustav Stickley who invited Unwin to contribute a 28-part series to his publication *The Craftsman*. The articles appeared between 1910 and 1912 and photographs of the house were featured.

We will never know what Clarice Cliff's initial thoughts were when she moved into the house in 1940. Leaving behind her small but tasteful flat in Snow Hill, she certainly must have found the four-bedroom home extremely spacious. Though modest by Parker and Unwin criteria, it was a manor by Stoke-on-Trent standards. As well as the sheer size of the house, Clarice may have found its decor overpowering as Colley Shorter had imposed his own ebullient taste on the intrinsically simple interior design. The lounge was furnished with a European chinoiserie table, a French Second Empire cabinet and a Louis XV chair. A large Indian Ivory carving occupied a side table, and in the hallway was a William & Mary chair. The window-mounted glass display cabinet was full of oriental figures, and everywhere were pieces of Chinese Export blue and white porcelain and Japanese wood-block prints that Colley had bought from Charles Goodfellow. It is hard to imagine exactly how Clarice would have felt about this heavy opulence, which rather contrasted with the chest of drawers she had painted orange and black as a child!

However, the role of mistress of Chetwynd House was not one that daunted Clarice. During the thirties she had met people from every level of society. She had also enthusiastically read imaginative stories set in grandiose houses, such as the *Jalna* novels written by Mazo de la Roche. The heroine of another of

for their places.' Whilst in their essays they argued for aspect so that the house was as light as possible in the main rooms, they also argued for prospect, 'a pleasant outlook is a boon only less great than a sunny aspect'.

The Goodfellow House represents an early example of Parker and Unwin's architectural collaboration before they built a reputation as town planners, particularly for their success in the evolution of the garden city movement. Both men were intensely devoted to the progression of architecture and Unwin was a member of his local group of William Morris's Socialist

RIGHT: DELECIA PANSIES ON A BON JOUR BREAKFAST TRIO AND AN OCTAGONAL PLATE.

Clarice's favourites, Daphne du Maurier's 1938 novel *Rebecca*, had moved from a simple life to one in a grand home. Clarice encountered few problems with this transition in her life, and learned how to organize the housekeeper and the cook, entertain Colley's guests and amuse herself when he went into the factory. Colley Shorter had no problems adapting to having his new wife in the house, although his family visited a great deal less once she had moved in, as he chose to put her first. Whereas publicly he was a stern, ruthless businessman, he was extremely sentimental and romantic with Clarice.

BELOW: THE GARDEN AND VALLEY BEYOND, LOOKING DUE SOUTH FROM THE HOUSE.

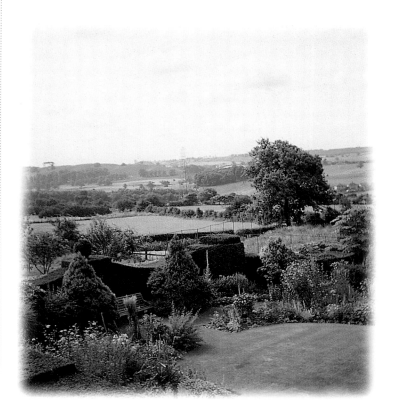

In 1940 Colley took on a young man named Norman Smith to replace Eric Grindley and other managers who had enlisted in the services. He treated him like a son, grooming him in all aspects of the trade. Norman recalled, 'Colley Shorter spent a great deal of time every afternoon at Newport. At 3.30 I had to take across the letters he had dictated for signature at Wilkinson's. It was tea-time and he would be with Clarice in her office-cum-studio. I was invited in and stood kind of "cap in hand" while Colley signed the letters. You virtually touched your forelock when you approached the owner of the factory.'

Colley persisted in going to the factory but as a concession to rationing he often left his Rolls Royce in the garage and drove himself and Clarice in his horse and buggy. However, by 1942, as the effects of the war became more keenly felt, they had little to do as the factory had virtually closed down. Instead, they spent a lot of time together, gardening throughout the summer, and in the winter retreating into the inglenook.

When the war finally ended in 1945, Clarice came out of semi-retirement to oversee the production of suitable ware. Hilda Lovatt contacted some of the old *Bizarre* 'girls' and a little hand-painting for export was introduced. The small team worked in a new *Bizarre* shop established at Wilkinson's, as Newport was never used after the war, although Clarice nostalgically issued ware with a *Newport Pottery* mark. Production of *Celtic Harvest* resumed, *My Garden* was reintroduced in softer colours and matt glazes. Naturally *Crocus* was also done, and fortunately the original paintress Ethel Barrow returned. Even though she and the other paintresses were now wives and mothers, they still called themselves the *Bizarre* 'girls'. Colley, as energetic as ever, threw himself back into his work although by this time he was 63 years old. As his youngest daughter Joan

ABOVE: A CONVOLVULUS WALLPOCKET AND OPHELIA ON A TURQUOISE GLAZE PLATE, 1938 TO 1955.

had married a Canadian Air Force officer and returned with him to Canada, Colley immediately concentrated the companies' essential exports on the North American market as this also gave him the opportunity to visit her.

North America favoured more traditional styles so Clarice was restricted to underglaze prints, although some hand-enamelling was done. *Georgian,* a conservative tableware shape, was offered with simple turquoise and gold, or green and gold, hand-painted edge lining. Traditional Staffordshire prints of small flowers were also used on it, and Clarice even called one with small roses *Nancy,* doubtless after her much loved niece. Two popular all-over patterns were *Ophelia,* a design of flowers in a

vase first produced just before the war, and *Chelsea Basket*, which featured flowers in a basket. The magical *Clarice Cliff* tradename helped sell conservative printed patterns in large quantities overseas, so the factory remained prosperous. However, regulations did not permit the sale of decorated ware on the home market until 1952, so Clarice had no scope to experiment at this time.

Clarice's sister Ethel had married Arthur Steel – who had worked at Wedgwood before the war – and he joined the

BELOW: CLARICE ENJOYING HER GARDEN WITH A FRIEND IN A PHOTOGRAPH CAPTIONED BY COLLEY: 'I WILL BRING YOU A BUNCH OF RARE FLOWERS, ROOTS AND ALL!'

ABOVE: WATER LILIES ON THE CARP POND.

works, assisting Colley Shorter and Bernard Ashton in the modernization of the equipment. The old bottle ovens were demolished and Colley sentimentally took a picture of them. In their place rose a new continuous-firing twin glost-kiln, and a biscuit-firing kiln. Bernard recalled that 'they made Wilkinson's one of the most self-contained factories in Stoke because they still made their.own glazes and milled their own clay'. He was in awe of Clarice, and her reputation preceded her. 'She was always a perfect lady. Whenever she walked around she always had this air of grace, gentleness and femininity. She always arrived with Colley at about 9.30 am weekdays, but it was a rit-

ual with Colley that he came in at 11 o'clock on Saturday mornings in his Rolls, wearing a Panama hat, and in winter, had a great big shawl on his shoulders.'

With her role as designer now less demanding, Colley persuaded Clarice to join him on a 'sales trip'. Norman Smith recalled that they were away for almost four months from October 1949. 'I drove them to the docks where they were met by the representative of the travel agents, who took us to the dining-room to see them off with a drink and a meal. In those days travel was lavish. They went across on the *Saxonia* and visited Winnipeg, Vancouver, and spent Christmas in Victoria with Joan.' Colley was delighted that he was now a grandfather.

During their visit to Cananda, they were interviewed by the local press, and Clarice was quoted as saying, 'English women are so starved of colour, so tired of the undecorated china they can buy, that there is a blooming of an era of strong colour. It will be well received in America bringing with it a spot of colour to the neutral tones in the decor of the new house built on functional lines.'

Clarice did not leave the factory without a designer during her trips; she appointed Eric Elliot – a student she employed directly from the Burslem School of Art. She and Colley were now free to go on more sales trips. During another Canadian visit in the early fifties Colley heard that the Duke and Duchess of Windsor were also visiting. Never slow to seize any opportunity he sent them his card to pay his respects. He was granted an audience and in due course Clarice and Colley presented themselves. Just the Duke was there. Clarice reminded him that they had met in 1933 at an exhibition, and he said, 'I remember, you're the lady who taught me to turn a plate over!'

As they enjoyed North America together, the builders made alterations to Chetwynd House. The internal courtyard was covered with a roof that was largely glazed. This meant the loss of one of the key features Parker and Unwin had incorporated fifty years previously. Clarice's niece Nancy recalls this happening. 'When you went into the house, there was a passage leading to a hall surrounding an open square. There was a low wall with panes of glass in frames right up to the roof on all four sides, and the passage went all the way round. In the middle was a huge tree and the branches spread right out over the roof. Imagine what it was like, there were doors leading off every-

BELOW: A CLOSE-UP OF NASTURIUM ON AN OBLONG SANDWICH TRAY.

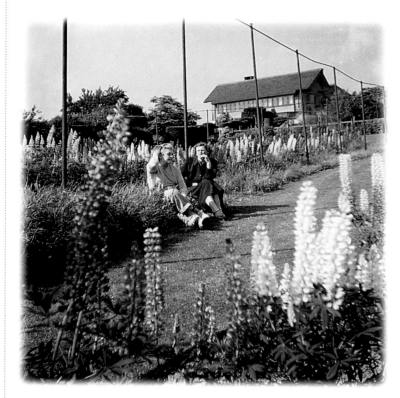

ABOVE: CLARICE CLIFF AND A FRIEND IN 1951 ON THE OLD ASH TENNIS COURTS, WHICH HAD REVERTED TO A BED OF SEMI-WILD RUSSELL LUPINS.

where. The tree was removed, and a large skylight was put in.'

Parker and Unwin's architectural partnership, seeded by the work on Chetwynd House, had flourished in 1902 when they had won the competition to design Britain's first 'garden city' at Letchworth in Hertfordshire. Knighted in 1932, Sir Raymond Unwin died in 1940. Barry Parker lived until 1947, just two years before the changes were made.

Clarice and Colley loved the light, bright room created underneath the new glass roof over the courtyard. It opened to each part of the house, and became the main living space where they spent many contented hours. It was only known to a few close friends that, underneath a loose carpet, the room

had a wooden dance floor. They had this installed at the time of the changes. One can only speculate how often they rolled back the carpet and turned on the gramophone!

Without doubt, Clarice and Colley's joint passion was now the garden. With the services of up to five gardeners they threw themselves into restoring it to its full glory after the wartime hibernation. Colley generally put on an old straw hat and helped in a leisurely fashion while Clarice busied herself from early until late. They both ensured the garden was kept scrupulously tidy, and there was never a weed in sight. Attractive

BELOW: COLLEY SHORTER SEEN WITH HIS PRIZE GLADIOLI PHOTOGRAPHED BY CLARICE CLIFF IN 1958.

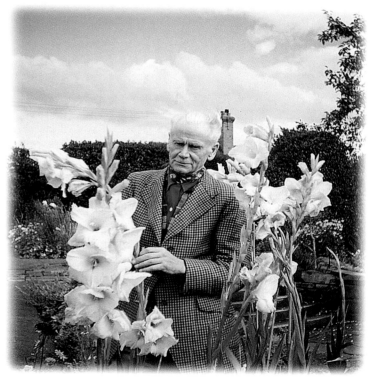

borders with lawned areas in between were separated from the rest of the garden by mature holly and yew hedges. The garden then fell away gently to the south and south-east. Steps led from level to level, and each had a garden bench to make the most of the view. When Colley's nephew John Brereton Shorter and his family visited in the summer they were often entertained outdoors, and the children were fascinated by a pond where carp sheltered under a mass of white water lilies. Near its southern edge the garden reverted to wild meadow

BELOW FANTASQUE IDYLL, THE POPULAR THIRTIES DESIGN OF A LADY IN A GARDEN.

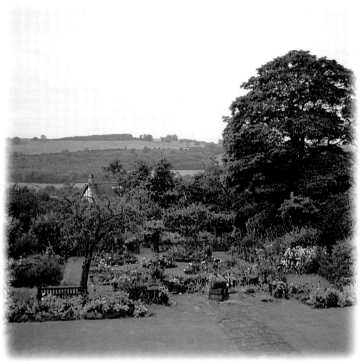

ABOVE : THE GARDEN IN 'HIGH SUMMER' IN 1957.

where Colley kept his favourite horse, Mary. He would ride her at weekends or occasionally harness her to his trap to drive into the works. The bottom of the garden consisted of half an acre of allotments, let to local people at a peppercorn rent.

In the thirties Colley had employed factory workers to add paths to divide the areas of the garden. One apocryphal story holds that the factory had a high percentage of faulty pieces when firing *Inspiration* ware, and he had instructed that it be broken into similar-sized pieces and laid as crazy paving. Sadly for today's collectors, if this *Inspiration* path ever existed, it has long since disappeared!

Colley had bought a stereoscopic camera in North America

73

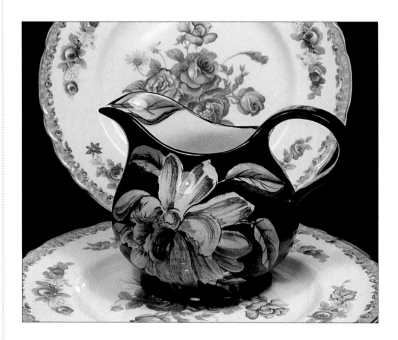

Above: The Paris design on a Novota shape jug, and dinnerware in a Fifties lithograph pattern.

by Elliot, featured large colourful fruit, but the majority were floral. By 1953 many designs were in production, but bold and colourful ones such as *Paris, Orchid* and *Magnolia* were not as commercial as the designs of a new generation of Staffordshire artists whose work dominated the home market. Clarice did excel in producing some stylish streamlined fifties' shapes, proving that her modelling skills were still strong. The *Novota* range consisted of nearly twenty shapes, combining fluid forms with adaptations of some of her pre-war ones, such as the *Daffodil* shape 450 vase. These were first decorated in two-tone glazes with simple printed-leaf motifs to the edges, but fussier decorations were created for overseas markets.

Clarice was now 54 years of age and preferred to direct the

Right: Clarice Cliff under an arch of Rose danse de feu in the Chetwynd House garden in 1951. The original slide is captioned 'Two reasons for going back to England' in Colley Shorter's handwriting.

Below: Clarice Cliff's Novota shape range, in a simple printed leaf design.

that took pairs of slides that gave a three-dimensional image when seen through a special viewer. He took photographs in Canada to show his friends in England, and vice versa. One of his favourites was of Clarice seated with a kitten on her lap in the middle of an arch of the rose 'Danse de feu'. Colley captioned this slide 'Two reasons for going back to England'. Neither his competitors nor his workers in the Potteries had any idea of the romantic side of this autocratic man.

In 1952, when wartime regulations were removed, Clarice was finally able to apply herself again as a designer. With Aubrey Dunn, who now supervised the decorating shop, and Eric Elliot, she evolved a number of patterns. *Sunkissed,* a range designed

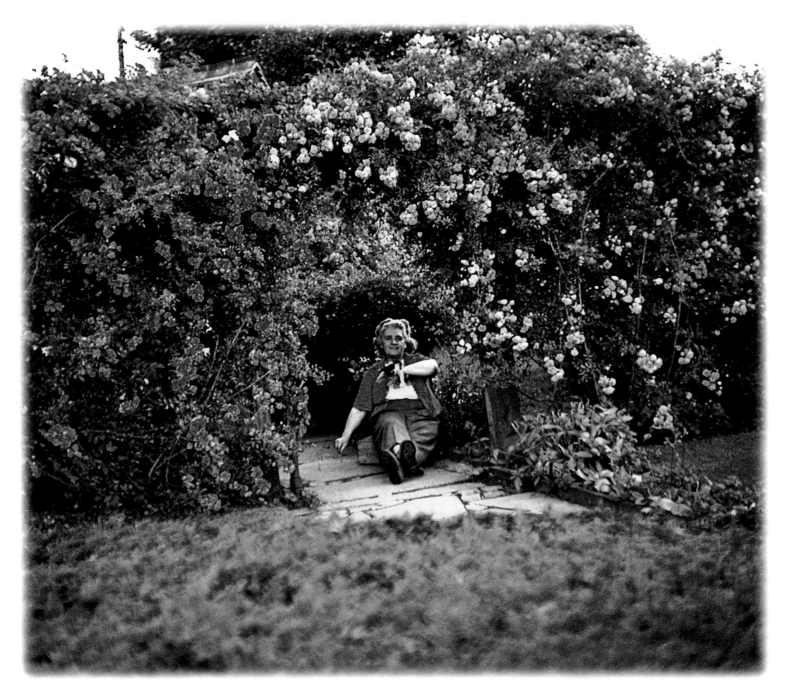

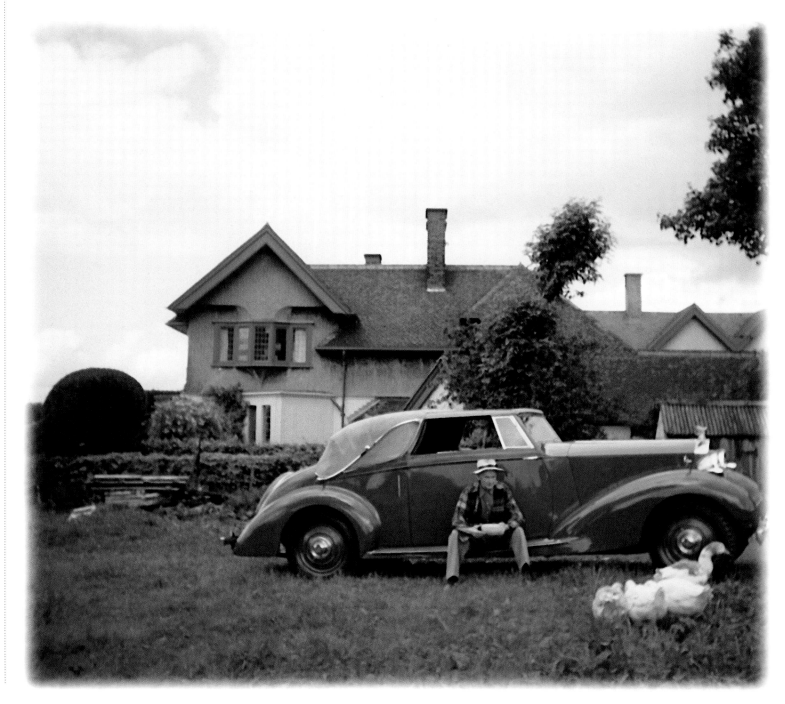

drive that had fuelled *Bizarre* towards rejuvenating Chetwynd House's garden. Her mark was firmly made in the choice of colourful annuals and bedding plants and naturally the season began with her favourite, crocus. The rockery near the top terrace abounded with the rich blues of aubretia, pink dianthus and tulips in the spring, and Clarice planted saxifrage and *Cerastium* 'Snow in Summer' amongst the stone steps. Near the house were variously coloured, splendid hydrangeas, and Clarice captured these in a 'picture postcard' shot with Chetwynd House behind. Further down the garden a number of established rhododendrons were covered in pale blooms every spring. A patch of yellow polyanthus perhaps reminded Clarice of those her mother grew at the Edward Street home.

Colley had suffered from rheumatism for years, and some days stayed with Clarice rather than going into the works. He was fond of flowering trees and the garden boasted an *Acacia* 'Prickly Tree' and a *Wisteria sinensis* trained to a standard tree form. The pendant purple flowers hung over a ring of rose bushes. He had planted Russell Lupins many years before and although a cultivated patch near the house retained the wide colour range for which the strain was renowned, a huge patch had self-sown and reverted to mainly blue. Colley let them rampage over the now disused tennis court as they were his favourite flower, and he photographed Clarice with them.

By August, Chetwynd House's garden was still ablaze with colour when many other English country gardens were past their prime. Tall *Rudbeckia,* yellow daisy-type flowers with black centres, bloomed next to phlox and pale-pink Japanese anemones. The garden was also well stocked with dahlias which

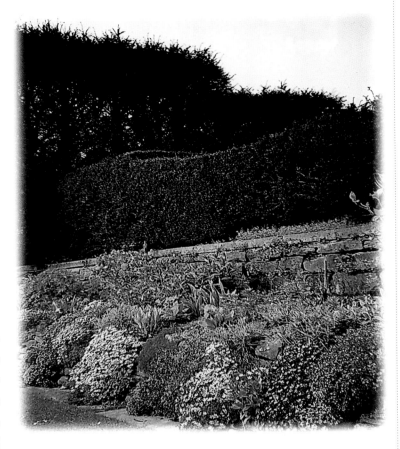

ABOVE: A TERRACE EDGED WITH AUBRETIA

harked back to Clarice's *Latona* floral range. She toured the garden with her basket cutting these, roses and gladioli, to arrange in tall vases in the house.

Colley continued as the factories' main overseas salesman, and when he was away Clarice's family often visited. Nancy, who was now in her thirties, noticed that the flowers her 'Auntie Clarice' had painted in the *Bizarre* years were now growing in the garden. Vibrant red poppies with red and pale-pink peonies

LEFT: COLLEY SHORTER WITH HIS TREASURED 1938 ROLLS ROYCE, IN FRONT OF THE SOUTH-EASTERN ELEVATION OF CHETWYND HOUSE, IN A PHOTOGRAPH TAKEN BY CLARICE CLIFF IN 1953.

against a yew hedge captured the same colours as the 1931 *Gardenia* design. Tea roses were interplanted with Canterbury bells and delphiniums. Set amongst these flowers Chetwynd House began to resemble a real incarnation of one of Clarice's 'cottage in a garden' scenes, such as her 1936 *Chalet*.

Clarice fondly recalled her trips in 'Jenny' and, not wanting to part with the car, had let it languish in the garage. Perhaps nostalgia motivated her to take it to a local dealer who was given a large budget to return the car to its former glory. However, when she and Colley went to nurseries to replenish the garden at weekends, they generally went in his beloved Rolls Royce. They bought many old stone garden ornaments and troughs, and Clarice dotted these around the garden; one was planted with *Sempervivum* (Houseleeks).

Every year Colley and Clarice's holidays grew longer. He escorted her to all the places he had first visited decades before, including Bermuda, America and Canada – one trip to Europe ended in an extended chauffeur-driven tour of Italy. Their photographs also record a trip to France, nostalgically recalling their secret visit in the twenties. This time they stayed in Paris only briefly, preferring to linger in the famous garden at Versailles. Clarice also took several striking portraits of Colley, capturing a man who was still handsome in his seventies. In Britain they visited formal gardens in the Cotswolds, going to Broadway and Blenheim, and in high summer they ventured as far south as Devon and Cornwall.

By 1961 Colley was 79 years old, and often when Clarice spent hours in the garden he would watch from the sun porch. He had persisted in trying to run the factory, but the loss of key staff meant it inevitably began to run down. Unable to go on foreign sales trips he delegated these to Norman Smith, who Clarice and Colley treated as the son they never had. Norman did a world tour, ending in New Zealand in 1961 where he was pictured in the local press with the representative of Robert Raine of Wellington.

Sometimes after a day at the factory, Norman would go to see Clarice and Colley.

When I visited in the summer we would sit in the window seat looking down the garden and discuss the factory. Clarice was a very keen gardener. She loved plants. The garden was covered in hydrangeas and roses. They also had a small cultivated field, so they hired a machine to cut the hay and really enjoyed this. Colley would come into the house with a basket of crab apples from his orchard and hand them out. Then Clarice would say, 'Colley, it's a quarter to seven', so the radio was turned on for The Archers. We would keep quiet until it finished, and then we'd start chatting again.

In December 1963 Colley Shorter died, aged 81. Clarice was deeply upset and, after the funeral, realized she had no alternative but to sell the factories they had both loved so much. She negotiated the sale to Midwinter Pottery, ensuring that her few remaining paintresses would keep their jobs. Chetwynd House and its contents were left to her during her lifetime after which they had agreed the bulk of the estate would go to Joan Shorter, as it seems Colley never healed a rift with Margaret.

RIGHT: CHALET, ON A 13" WALL PLAQUE, 1936.

ABOVE: CHETWYND HOUSE GARDEN CAPTURED ON A CRISP WINTER MORNING BY CLARICE.

Losing her husband and the factories so quickly was a blow from which Clarice never fully recovered. Her sisters and their children visited Chetwynd House but she avoided answering the telephone, and became insular. She spent the winters cleaning the mass of antiques and fine art, and arranged for the donation of a selection of these in Colley's memory to the Newcastle-under-Lyme museum. In the summer she often stayed in the garden from early morning until sunset. She had

a nightly chat on the telephone with her sister Ethel, and maintained her friendship with Hilda Lovatt who had retired to North Wales. In a 'thank you' letter for a card Hilda had sent for her sixty-seventh birthday, Clarice recorded the quiet life she now led.

It is time that I was in bed I know, 11.30. Have just been into the field to fasten up the geese. I bought them to keep the grass down, and in spite of wire netting, they scramble over it somehow and get into the big field I rented to the farmer. I shall have him on my tail in a week or two when the grass begins to grow. While the weather is frosty they eat me out of house and home – cabbage, potatoes, turnips, bread. They love apples but have to be content with a few peelings occasionally. Thank you for the birthday card, it is just like a hand-painting and makes me think and wish for spring.

Clarice still had a cook and housekeeper who came in every day. Although she could have continued to employ many gardeners, she was economical with the legacy Colley had entrusted to her, and preferred to do much of the gardening herself. However, she did employ Reg Lamb, who had first worked with her at Wilkinson's in 1919. Despite their ages they clearly rose to the challenge of the acres of garden. A series of letters she wrote to Hilda often referred to the garden, and showed she had not lost her sense of humour: 'I bought a rotary mower, and now I have taught myself how to use it. I am quite proud of my efforts, but winding it up and walking miles behind it especially up and down

RIGHT: THE CHETWYND HOUSE GARDEN IN OCTOBER 1957.

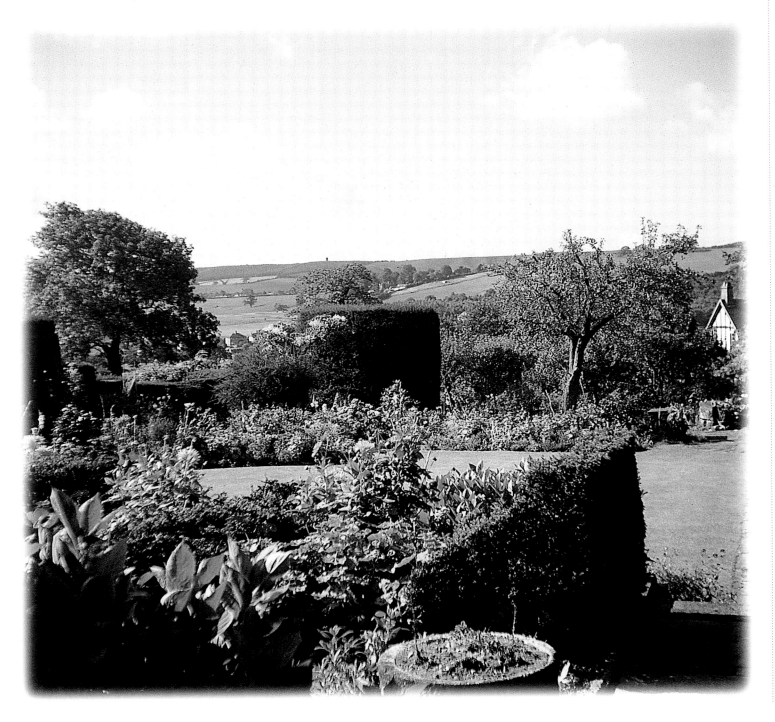

banks, have developed a few aching muscles, so I thought about you and got myself some Elliman's!'

On hot summer days she would take a break from the gardening and drive in 'Jenny' to get ice-creams for her and Reg from a nearby shop. Only the winter stopped her work on the garden, and then Reg helped indoors, as she noted in another letter.

We have been having rather an awkward time. Reg was giving a hand indoors and went outside to fetch something. After quite a while he came back and fell across the floor in a faint – scared the living daylights out of me! After brandy, hot tea and a lie down it appeared that he had fallen on the ice, and was in considerable pain. The outcome was that he had cracked his right shoulder and was away for seven weeks. Then of course, I had to do a silly thing, went out into the cold east wind and gave myself inflammation of the bowels. Goodness, I do not want any more pain like that thank you very much!

Clarice was always ready to dispense gardening hints, often writing anecdotes in her letters. 'I am glad [your] Jasmine is making growth, it seems to take some time to get really established and then grows fairly quickly. Mine has been in flower for quite a few weeks now. Don't be afraid to cut a few snips off, it seems to encourage it.' She proudly told Hilda of her spring flowers in another letter. 'We have had a good show of crocus, daffodils and forsythia. I have been pleased with the heather too, a nice bit of colour seen from the window. I have only been around the garden twice and it looks as though we have lost quite a few rose trees. There is a lot of pruning waiting to be done, but I am afraid it will have to wait until the cold winds have ceased.

It is lovely to see the new growth appearing and to look forward to a few months without frost and cold.'

Clarice still relished driving in the Staffordshire countryside, now often alone. 'The dark nights seem to have come more quickly this year somehow, but the colours of the countryside are very beautiful especially when there is a bit of sunshine.'

Meeting Marjory Higginson when she was shopping she told her former *Bizarre* 'girl' how fondly she looked back on the good times of the thirties. Clarice wrote to Hilda, 'My sister Ethel meets one or two of my "old girls" occasionally and they send messages to me.' However, Clarice clearly did not feel the need to socialize with her workers, but returned to being the quiet, shy person whose ability had surprised Colley Shorter and led to the *Bizarre* years.

In 1971, an advertisement in *The Times*, asking anyone who knew the whereabouts of Clarice Cliff to contact Brighton Museum, was noticed by Guy Shorter who was now 87. The museum wanted her to assist with an exhibition of her work they were to hold. She did this reluctantly, refused to meet anyone personally, but was persuaded to write a few notes for the catalogue. She was, however, stalwart that she had no intention of visiting the exhibition and told none of her family about it until it had closed.

Clarice spent her final summer quietly pottering around her garden and died suddenly on 23 October 1972. Within months the valuable contents of Chetwynd House were auctioned and Nancy recalled that, 'the house plus the antiques, plus the money in the bank, made a total of £240,000!' The house was purchased for £57,000 by a local builder who destroyed most of the garden to make way for bungalows.

It was fortunate that, at the end of the seventies, Chetwynd

House was bought by Professor Flavia Swann — a historian of art, architecture and design — as she found herself consumed by its fascinating history. Her informed restoration of the building inspired her to seek out the original furniture, much of which had been sold in 1972, and she continues her search to this day. Being only the third person to dwell in the house, she was also intrigued by the story of Clarice and Colley, who had lived there a great deal longer than Charles Goodfellow. The famous couple's mark had been left on Parker and

ABOVE: AN AERIAL PHOTOGRAPH OF CHETWYND HOUSE AND THE EXTENSIVE GARDENS AS THEY WERE SHORTLY AFTER CLARICE'S DEATH IN 1972.

Unwin's early masterpiece, and Flavia celebrated their contribution by buying a few pieces of *Clarice Cliff* ware to stand on windowsills overlooking the remaining half-acre. Inevitably, her attention turned to the garden where she ensures that some of Clarice's flowers still bloom. Every spring a small patch of crocuses appear, and hydrangea bushes, peonies and roses still brace themselves against summer showers, as they did when Clarice devoted herself to the garden.

Nowadays, the highest terrace near the house is all that remains. Yet visitors to Chetwynd House can easily imagine that Clarice has only just been tending the garden and popped indoors to make tea for herself and Colley. Their different but complementary talents helped them change the course of British ceramic history. When they then combined their energies on Chetwynd House's garden, their last creative project, it

was a shared act of love.

Every year, members of the Clarice Cliff Collectors Club regard the visit to Chetwynd House as the highlight of their Convention. Standing in Clarice's garden, one senses it was a deserved reward for her hard working life. Lingering in the sun on the verandah, looking out at Clarice's flowers, one somehow feels an echo of those her 'girls' painted. In them she left us a wonderful gift. The feelings her flowers instil go all the way back to Clarice's childhood love of them, to the vivid enamel flowers of the *Bizarre* years, and to the ones she and Colley tended together. In her many floral designs she captured a unique beauty that lives on generation after generation. Every year, new admirers discover Clarice Cliff when they are enchanted by her simple *Crocus*. What more could she have wished for?

'Writing down the date makes me think — and I can hardly believe that the month we look forward to has gone. Today has been the loveliest full day we have had for some time and I have been cutting grass most of the day. It has been a case of waiting for the sudden heavy showers to dry up, and then dashing out to cut a patch, before the next downpour. The wind and rain played havoc with the peonies and roses — very depressing after the trouble one has taken with them. That's gardening!'

A BOUQUET FOR CLARICE CLIFF

Having collected Clarice Cliff's pottery since 1979, and spent part of virtually every day since researching her amazing story, occasionally I wonder if I am over-reacting to her work. Perhaps, at times, I have overcompensated for my admiration by being critical. But given that the 'establishment' both now and in the thirties has been slow to endorse the success the public bestow on her, I thought it was time she had some form of recognition. I asked Doreen Jenkins, an avid collector, to explain why Clarice Cliff the person and Clarice Cliff the designer arouse such fervent enthusiasm from so many people. Like Clarice, Doreen was an independent career woman in her younger years. Her informed and thoughtful opinions about the appeal of *Bizarre* have always impressed me. I suspect that if Doreen had been the one to knock on Clarice's door in the late sixties, she would have got into Chetwynd House. Sadly, earlier male devotees of Clarice's work who tried,

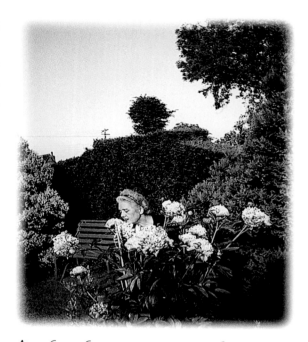

ABOVE: *CLARICE CLIFF WITH SOME PEONIES IN THE CHETWYND HOUSE GARDEN IN SPRING 1951, PHOTOGRAPHED BY COLLEY SHORTER.*

all failed. The enthusiasm of Doreen's tribute encourages us to consider what was so intriguing about this woman; naturally Doreen had no other option than to call her contribution *A Bouquet for Clarice Cliff*.

As each day passes, my admiration for Clarice Cliff grows more and more. Like her or not, the working-class girl from the Potteries – who rose to such world-wide prominence in the thirties and whose *Bizarre* pottery is now so eagerly collected and admired – is here to stay.

Growing up in a humble terraced house in Tunstall to then become the mistress of Chetwynd House must have been beyond the dreams of most young women in the Potteries, but Clarice eventually lived her dream. Her genius for design, the staggering success of her *Bizarre* ware, and the unequivocal love between her and Colley Shorter provided all the ingredients necessary for her remarkable life.

How I wish I could have met her. There would have been

many, many questions to ask. Yet somehow I think she would have been 'quite ordinary' in all kinds of ways, which intrigues me even more. Not for her the heady, new, celebrity style we now see daily in our newspapers or on television. One of her longest-serving paintresses, Marjory Higginson, clearly remembers Clarice as 'every inch a lady, quietly spoken, well dressed, and very reserved'. Another, Edna Cheetham, recalls her 'quiet air of authority'. Almost certainly she would have laughed at the merest reference to any hint of genius, dismissed my verbal drooling over her prolific and glorious array of patterns and pottery shapes, her vibrant colours and extraordinary concepts, and quietly muttered that 'it was all rather a long time ago'. However, I cannot help thinking that amongst her innermost thoughts she would have been pleased about our deriving so much sheer enjoyment from the unique use of colour and design she still brings into our lives today.

Why do we feel that collecting Clarice Cliff pottery is such an all-encompassing passion? Just what was Clarice Cliff's Unique Selling Point? Her enthusiasm for colour? Her flamboyant, non-conformist designs? Her almost gravity-defying pottery shapes? Can you imagine sitting in a small studio sketching in your pattern book a vase fashioned in the shape of a ship's bow, with a tube behind to hold flowers? Or visualizing a *red Gardenia* on a teapot shaped like a spaceship!? Who else but Clarice Cliff would mount such a gay thirties-style lady wearing the most flamboyant beach trousers you've ever seen, at the edge of an ashtray, almost saying 'Hi! Look at me!' And only Clarice would have thought of an exquisite range of table ornaments of dancing couples enjoying the Jazz Age musicians! For me, and I suspect many others, these are just a few of the many fascinating aspects of her *Bizarre* ware.

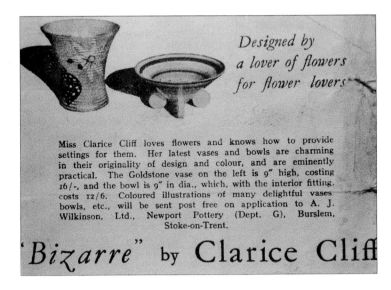

ABOVE: *A 1934 ADVERTISMENT WHICH CONFIRMS CLARICE'S LOVE OF FLOWERS. THE SHAPE 602 VASE IS GOLDSTONE WARE WITH A FLORAL MOTIF, THE CONICAL BOWL IN A BANDED DESIGN HAS THE LATER PASTILLE-SHAPED FEET.*

Clarice Cliff's completely new idea of painting abstract patterns on to old, unused stock was the perfect combination of imagination, practicality and uniqueness. Although her work also embraced the most innovative and eye-catching geometrics and landscapes, the majority of her output focused upon the everyday beauty of flowers. Crocuses, poppies, tulips, delphiniums, nasturtiums, marigolds, roses, lupins, lilies, petunias, asters, clematis, anemones and daisies – they flourish all over her pottery. In celebrating her great love of flowers, she captured the very essence of their appeal. She brought them alive, often reconstructed from their usual form and brightly coloured with her fresh, vibrant palette.

Two of her floral patterns immediately spring to mind. *Picasso Flower* shows how Cubism meets nature, with a bold geometric

flower bisected by a green stem. On *Chintz Blue,* blue, green and pink water-lily buds and leaves look like fried eggs on fabric. Complete ranges of her ware were florally inspired, such as the embossed *Marguerite* and *My Garden* series, and the tableware range inspired by the shape of a daffodil. Without doubt, Clarice Cliff excelled in floral design. No other thirties' designer produced ware that ranged from the cosy to the startlingly modern.

Where did Clarice's inspiration come from? Some of her sources have been well documented, but it must be remembered that it is often the simplest of memories that lingers and interweaves throughout one's life. The story, related by her mother, of the sweet-smelling honeysuckle her husband put into her hat all those years before seems to have been a lasting memory. I would like to think so. Clarice's immense love of flowers, landscapes and idyllic country life was surely born on those Sunday afternoon walks with her family after church, just as we are all inspired, many years later, by the memories of childhood experiences.

Although those of us with a sentimental nature may sometimes dwell on Clarice's relationship with her mentor Colley Shorter, I am sure that there were many lonely times for Clarice before they were able to marry. Yet, practical as ever, she would take her niece Nancy on countryside jaunts at the weekends, often discovering more flowers, tree shapes and landscape views which she could later interpret into new patterns. I wonder if she secretly yearned to share a cottage in the countryside with Colley, where the log fires were always burning.

Ultimately, after the years of professional success, she was able to marry the man she truly loved. Together they made a great team, each with their own diverse talents and personalities. But remember, it was Colley Shorter who recognized Clarice's talent and gave this bird her chance to fly. She repaid

him by making Wilkinson's and Newport Pottery two of the most successful in Britain.

Clarice would certainly have wanted me to hand out posies of gratitude to the one hundred 'girls' and 'boys' who decorated *Bizarre* during the thirties. Their patience, speed and dexterity with their 'pencils' meant that one minute they could create bold confident brushstrokes, the next fine, exacting lines, then on to tiny dots, edging, hatching, brash circles, squares, zig-zag lines, and large, luxuriant, dashing strokes. And they clearly revelled in learning such new techniques as etching, and 'swilling the paint around' for *Delecia.* What a variety! How did Clarice teach them to paint her patterns so intricately wrapped around so many outrageously shaped teapots, vases, table decorations, and 'fancies' such as inkwells, book-ends, miniature vases and smokers sets? It is hard to imagine 14- to 16-year-olds mastering so many skills today.

Being able to marry Colley must have made Clarice's world complete. With the *Bizarre* years behind them, they were able to relish more leisurely times together. Clarice seemed to enjoy playing a lesser role at the factory, knowing she could not recapture those crazy days of the thirties. She did the next best thing over the ensuing years: she brought her *Bizarre* pattern book home, and cast it like a mantle over Chetwynd House's garden!

Over seventy years after Clarice launched *Bizarre* its impact is just as great. Collectors abound not only throughout Britain, but also in Australia, New Zealand, South Africa and North America. These scattered collectors focus their year on auctions totally devoted to Clarice Cliff pottery in London. If you make your way there on a cold, foggy November day, you will know what I mean by the word *enthusiast.* For 'Cliffies' who have travelled from afar, it proves to be an exhilarating, exhausting and unforgettable experience.

ABOVE: CLARICE CLIFF'S PAINTRESSES IN THE BIZARRE 'SHOP' AT NEWPORT POTTERY FEATURED ON THE COVER OF THE DAILY SKETCH IN DECEMBER 1931.

Yet sceptics who refuse to acknowledge her talent have claimed time after time that 'the fad for Cliff will peter out'. On the contrary, 'Decomania' – a passion for appreciating and collecting all things from the twenties and thirties – has been growing apace in Britain for well over ten years. Art Deco fairs, once a three-times-a-year event in the East Midlands, now run somewhere every weekend in Britain. As for the Cliff fad petering out, the number of specialist auctions, events, books and articles devoted to her work is clear evidence that Clarice Cliff has never been more popular since her heyday. And, whereas at one time Clarice Cliff Collectors Club conventions were limited to Stoke-on-Trent, nowadays they are also held in Australia and New Zealand.

Personally, what pleases me is that Clarice Cliff was feted and recognised *in her own lifetime*. What immense satisfaction she must have derived, knowing her art pottery was appreciated by so many people all over the world. However, it is sad to note that she received no such acknowledgement from her peers in the Potteries or London's academia. Time and time again, Colley

Shorter championed her cause – *her talent* – throughout his life, vociferously charging across all social and professional boundaries. This was no more apparent than when he insisted her name feature alongside such prestigous artists of the day as Laura Knight, Frank Brangwyn, Duncan Grant, Vanessa Bell, Dod Proctor, John Armstrong, etc. on the backstamps of the *Artists in Industry Ware* in 1934. Luminaries from the art and design Establishment were outraged!

We shall never know how much this lack of recognition dismayed Clarice. Knowing something of Colley's character, I suspect it angered him considerably. As a Victorian gentleman he would have felt it was a question of *honour*. For her part, left alone in the seventies without the guiding shield of Colley, I understand her reticence to get involved in her first retrospective exhibition at Brighton. Together, I believe, they would have embraced their new-found publicity. Alone, it was probably meaningless.

The Establishment wreaked its 'revenge' – no formal recognition of Clarice Cliff's work, i.e. no royal honour, nor a commemorative plaque at either Tunstall, or at the old Newport Pottery site. I would go as far as saying that the public's appreciation of her art pottery has spearheaded the ten-year 'love affair' Britain is *still* experiencing with Art Deco, and now she is revered by collectors around the world. By rejecting the values of the Establishment, Clarice Cliff created *Crocus* and hundreds of other brightly coloured designs. Her work has become much more collectable than that of any of the so-called 'prestige' artists she worked with in 1934. Her talent, and fate, turned this *ordinary* woman into an *extraordinary* artist.

DOREEN JENKINS

PAINTING FANTASTIC FLOWERS TODAY

Clarice Cliff's modesty meant that even when the first exhibition of her work was held in 1972, she still did not explain her achievements in the thirties. Her artistic productivity had fired immense sales of *Bizarre* ware, and we now know that at its height the *Bizarre* and *Crocus* shops held around sixty hand-paintresses and four boys. Over thirty of Clarice's original paintresses have been interviewed since 1981. In recalling their former colleagues, we now have the names of over one hundred decorators Clarice employed between 1928

and 1940. As she never laid off her decorators even when the Depression was at its worst, this is clear evidence of the amazing success of *Bizarre* at a time when most potbanks were struggling to survive. In the early thirties designers such as Susie Cooper and Charlotte Rhead who worked nearby had less than ten decorators.

The hand-painting skills Clarice was so keen to protect, both before and after the war, still persist in small pockets in the Potteries. Josiah Wedgwood employ paintresses to produce their Clarice Cliff reproductions and have recently set up a hand-painting shop at the Alexandra Pottery in Tunstall, which ironically is where Clarice first saw paintresses work. There, experienced paintresses are teaching new recruits the art of hand-painting on glaze.

Clarice's 'girls' are still passing on the skills they learned over seventy years ago! Ethel Barrow who painted *Crocus* from 1928 to 1938, and then from 1948 to 1963, was invited back to 'Wilkinson's' in 1985 when it was owned by Midwinter. She advised them on what were the first hand-painted Clarice Cliff

LEFT: ETHEL BARROW'S WORKBENCH AT MIDWINTER IN 1985 WHEN SHE RE-CREATED CROCUS AND NASTURTIUM. NOTE THE DISHES OF FAT-OIL AND TURPENTINE.

RIGHT: MAY BLOSSOM ON A TRIESTE SHAPE PLATE, A DESIGN PAINTED BY MARJORY HIGGINSON IN 1935.

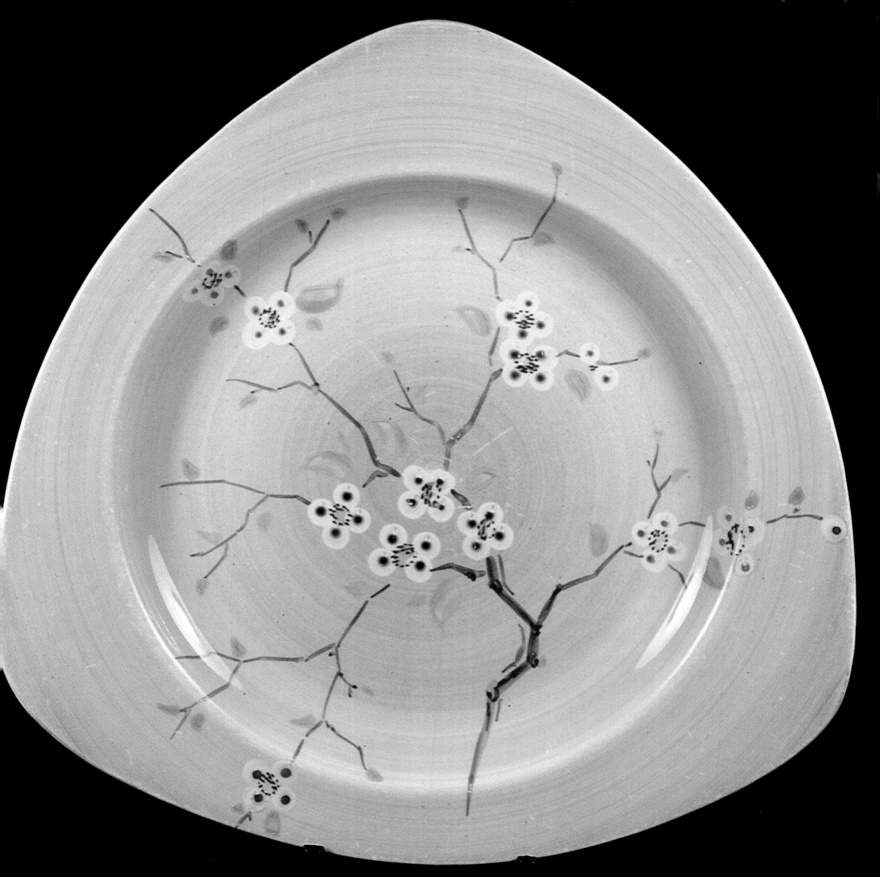

ABOVE: MARJORY HIGGINSON DECORATING HONITON ON A PLATE IN 1997.

'pencils' (brushes), powder colour mixed with fat oil and turps, and a lot of talent!

Bizarre 'girl' Marjory Higginson was so inspired by the revival of interest in Clarice Cliff pottery that from 1989 she 'unpacked her brushes' and started painting all over again. It helped that her husband Jim Hall had been an assistant on the bottle ovens at Newport. He converted their garage to accommodate a kiln. Although Marjory was primarily a bander and enameller for Clarice, she found she also had a talent for outlining, and produced *Gibraltar, House and Bridge* and many other complicated landscapes. The *Honiton* pattern she originated for Clarice in 1935 – with its unique 'finger-dabbed' flowers – was also revived and, as the photographs show, Marjory relished setting up her paintress's kit even in 1997.

Clarice Cliff's work is now studied in Britain as part of the national curriculum. Many students are so interested in the skills

BELOW: 'FINGER-DABBING' THE FLOWERS ONTO WET BANDING, BEFORE ADDING THE FREEHAND DETAIL.

reproductions. That day, in just a few minutes, she re-created *Nasturtium* on a plaque, copying it from a shape 515 bowl. The photograph shows how precise she was, even though she had not done it for fifty years!

The paintresses' bench gives an insight into the materials that were needed to paint Clarice Cliff flowers: a selection of

RIGHT: DETAIL OF THE FINISHED PATTERN.

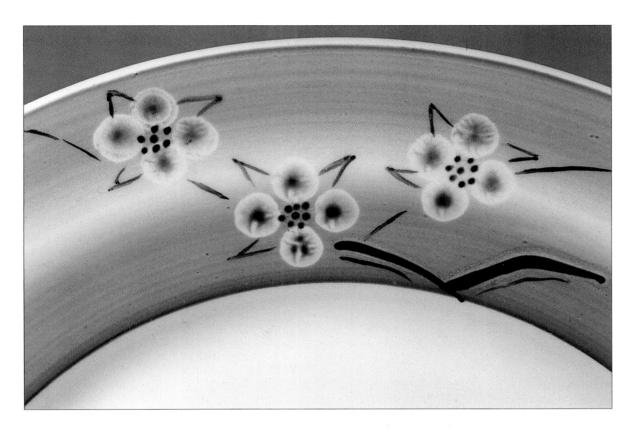

BELOW: HAND-PAINTING THE FINAL DETAIL TO COMPLETE THE FLOWERS.

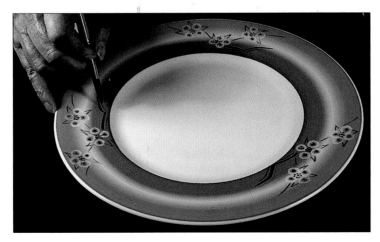

of hand-painting that colleges offer courses. Stoke-on-Trent College in Burslem actually managed to persuade Ethel Barrow to return to share her techniques with their students as recently as 1992 when she was 82 years old! Terry Abbotts, who was responsible for this, now holds classes in Staffordshire and Cheshire and also teaches hand-painting overseas, most recently in South Africa.

The skills Clarice Cliff nurtured in her 'girls' are being passed from generation to generation, and as young Staffordshire decorators pick up their brushes, new *fantastic flowers* will keep Clarice's legacy alive.

CLARICE'S FLORAL CATALOGUE

Compiled by Doreen Jenkins and Leonard Griffin

In compiling this floral A–Z listing we have been liberal, but not exhaustive, so you will find *Acornes, Berries* and *Cherries*, as they do after all come from flowers. Descriptions are followed by details of colourways, and then the year they were first issued. The ease with which hand-painted designs could be added, dropped or revived makes it impossible to be certain about final production dates. Suffice to say that even patterns found in large quantities were rarely produced for more than a year. Some were made only in a couple of batches over the course of a few weeks. The listing only covers designs which first appeared between 1928 and 1940.

Each design is followed by a grading to give an idea of its collectability, which is based on three factors: general appeal to collectors, auction prices provided by Christie's of South Kensington, and the results of a professional survey in 1994 of Clarice Cliff Collectors Club members, conducted by Rachel Steel's QuestionAir company. Only brightly painted designs qualify for a 'five-flower' grading, her more typical *Crocus* and *Rhodanthe* providing the average 'three-flower' rating. Designs which were just small motifs or were printed are rated as one or two 'flowers' although on good shapes even these can be quite expensive.

Assessing the importance of Clarice's floral designs – and therefore their value – is impossible to do without looking at their relative value to collectors. One might expect a vast difference in value on comparing the five-inch *Conical* sugar dredger with the eighteen-inch charger, but they show the appeal of her ware perfectly, as size really does not count. The only known example of a *Conical* dredger in *Gardenia* cost over £2,000 at Christie's, but the much larger *Delecia Pansies* charger was only £1,200 more. The cost of the *Gardenia* dredger would have bought a complete, rare and very colourful *Red Tulip* tankard-shape coffeeset for six in Christie's November 1997 sale.

Simpler, partly printed designs such as *Solomon's Seal, Nemesia* and *Fuchsia* are much more collectable when found on an Art Deco shape such as the *Stamford* teapot, rather than on just a single dinner plate.

Modelled ware such as *My Garden* was less valuable than the *Bizarre* patterns but recently has become more collectable, so small vases cost around £150, larger ones £200–£300. However, examples from 1937 to 1940, or post-war, in mushroom glazes with less colourful flowers are much less valuable. *Celtic Harvest* is a smaller range and less collectable, as is the *Scraphito* range.

The complexity of this listing is further proof of Clarice's productivity and, like her designs, our grading will doubtless cause controversy, for she really did design something for everyone!

RIGHT: A BOUQUET WALL MEDALLION SHAPE 553.

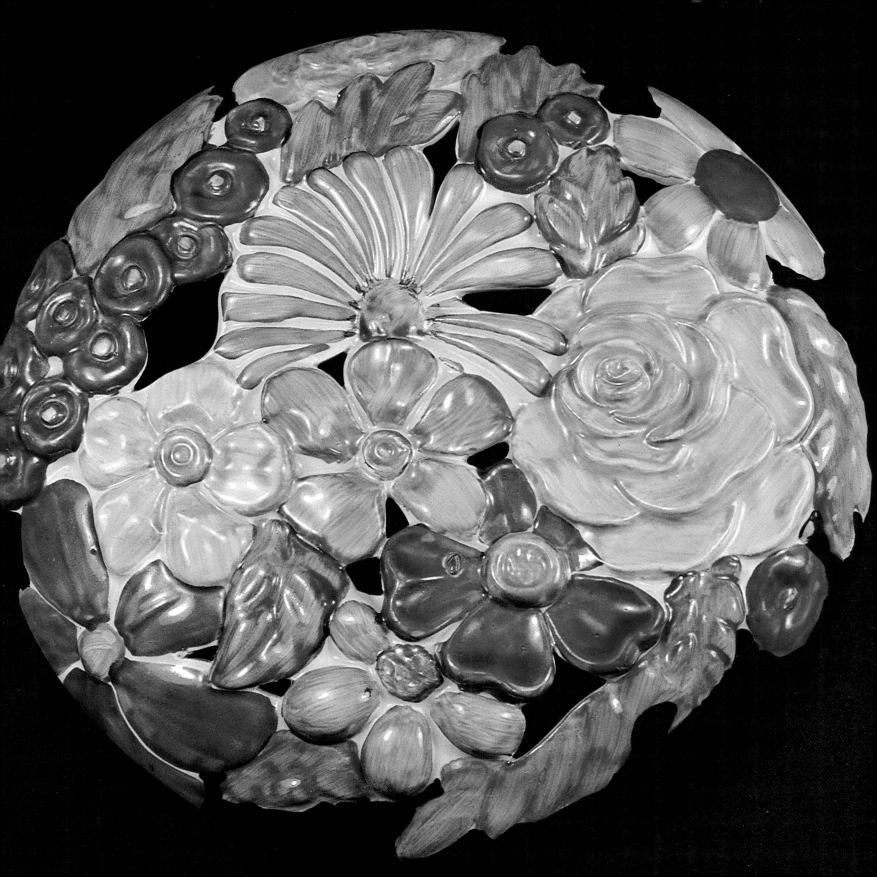

(At the time of publication, £1 equalled $1.63, therefore £1,000 equalled $1,630)

✿✿✿✿✿ The most vividly coloured, hand-painted, all-over floral designs mainly dating from 1929 to 1935, which tend to be found on her most collectable shapes. A large vase would cost £750–£2,000; a small vase £300–£1,000; an *Early Morning* set £1,750–£4,000; a small fancy £150–£500.

✿✿✿✿ Brightly coloured, hand-painted designs, either in a smaller range of colours or only partially covering ware. A large vase would cost £500–£1,000; a small vase £250–£600; an *Early Morning* set £1,250–£2,500; a small fancy £150–£400.

✿✿✿ Brightly coloured, hand-painted designs which only partially cover ware, or have *Delecia* or *Café-au-lait* finish. A large vase would cost £400–£800; a small vase £200–£500; an *Early Morning* set £1,000–£2,000; a small fancy £100–£300.

✿✿ Less collectable hand-painted designs, or hand-painted designs produced only as a 'shoulder pattern' – leaving much of the ware plain – and the more important printed designs. This is mainly functional tableware, and so less sought by collectors. Values unpredictable, but mainly under £100 for a plate; £50–£100 for a cup and saucer; £100–£250 for a teapot or coffeepot.

✿ A printed or lithographed floral design made just for tableware, with little or no hand-painting – not particularly collectable.

Acornes: Red acorns with green and brown leaves, with *Delecia* runnings (1934) ✿✿

Amberose: A yellow and pink rose with smaller roses and leaves amidst circular bands (1933) ✿✿✿

Anemone: Realistically painted flowers sometimes with runnings, in full or shoulder pattern (1937) ✿✿

Appliqué: Florals in this mainly landscape range included *Appliqué Blossom* – clematis and lilac flowers against a trellis (1930) ✿✿✿✿ *Appliqué Eden* – a large brown flower surrounded by orange flowers, a blue and green landscape 1931 ✿✿✿✿; *Appliqué Garden* – a curvy-trunked tree with light- and dark-blue foliage in front of a garden full of flowers (1931) ✿✿✿✿✿; *Appliqué Idyll* – a crinoline lady under a fruit tree in a formal garden full of flowers, with black/red/black banding. Later, under the *Fantasque* range, the banding was changed to pastel colours (1931–37) ✿✿✿✿✿

Aurea: see *Rhodanthe* (1934) ✿✿✿

Bamboo: A tree with orange and yellow etched *Rhodanthe* flowers and green leaves; sometimes with an oriental hut (1934) ✿✿

Berries: A cluster of red and orange berries with leaves among yellow and green blocks (1930) ✿✿✿✿✿

Black Flower: A stencilled black flower and leaves on a multicoloured striped ground (1929) ✿✿✿✿

Blossom: see *Appliqué* and *Latona* ranges

Blue Daisy: A freehand blue, pink and orange daisy with complex lines and curves (1930) ✿✿✿

Blue-Eyed Marigolds: Outlined orange flowers with blue centres and clear, crescent-shaped leaves, on a black ground (1930) ✿✿✿✿

Blue Ribbon: Freehand-painted orange flowers with purple centres amongst blue, yellow and green ribbons (1932) ✿✿✿

Braidwood: Powder-blue cornflowers with green leaves above geometric hatching. Mainly found in Australia (1935) ✿✿

Brunella: Blue-and-rust stylized flowers as an edge motif, very similar to *Ravel* (1929) ✿✿

Cabbage Flower: Green and brown flowers next to heavily brushstroked brown crescents with red and brown leaves and wavy yellow lines above (1934) ✿✿

Café-au-lait: The name for a technique of completely or partially stippling a colour on ware, which then had a design added over it. Introduced in 1931 many designs from then until 1933 are found in this style. Floral examples include *Gardenia* and *Red Tulip*.

Canterbury Bells: Bluebell flowers with others in orange and yellow, with dark-brown *Café-au-lait* above, yellow below (1932) ✿✿✿

Capri: A simple outlined garden pattern

RIGHT: Cabbage flower on a later Yo Yo vase shape 640, a Pink Pearls 366 vase, a shape 342 in Windbells and Crepe-de-Chine on a Conical teapot.

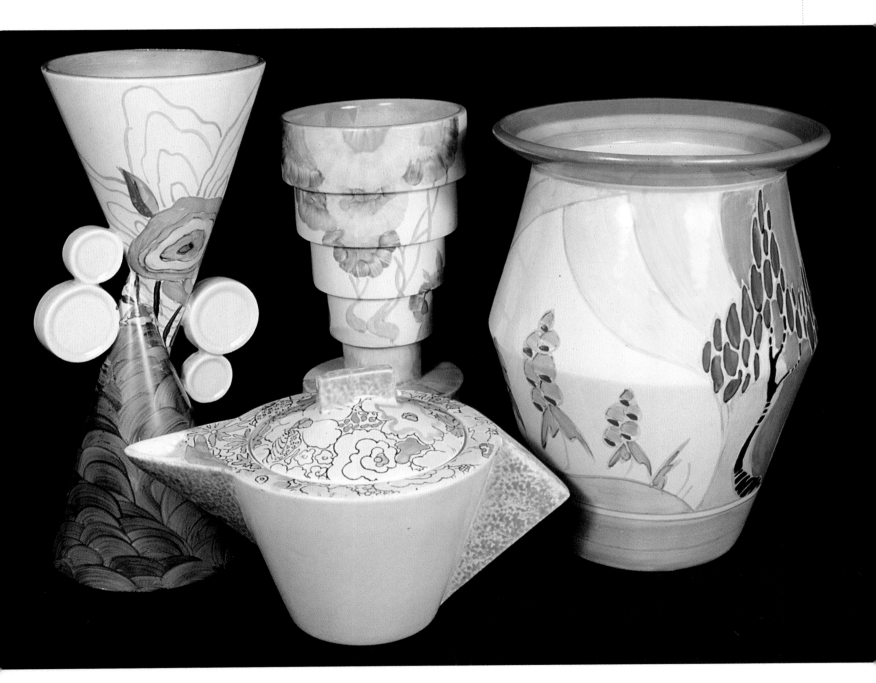

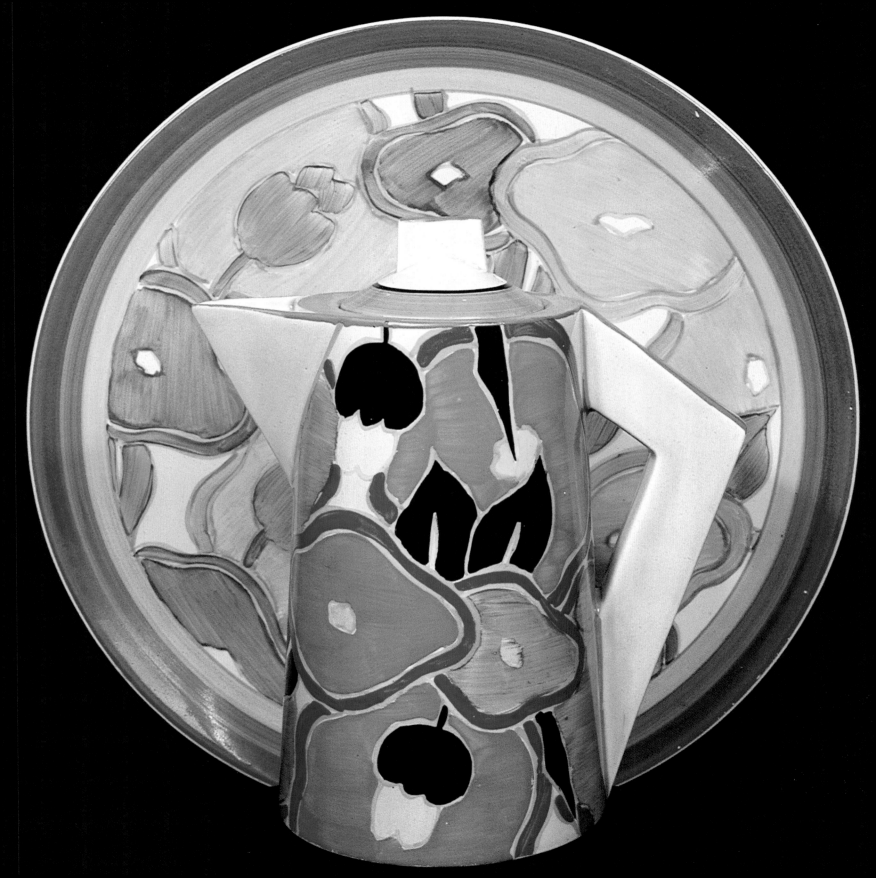

with orange and yellow flowers, brown and yellow trees; covered with circular banding. Also in green, and in a rare blue colourway (1935) ✿✿✿

Cherry: Blue fruit with purple leaves, outlined in jade (1929) ✿✿✿

Cherry Blossom: A delicate tree featuring small blossoms (made with fingertips) over rust and green *Delecia* runnings (1935) ✿✿

Chintz: Water lilies, buds and leaves, resembling a fabric. Most common colourways are *Chintz Blue*, then *Chintz Orange*, and a *Chintz Green* variation is also known (1932) ✿✿✿✿

Chloris: A sophisticated full-colour print of hollyhocks, daffodils and tulips with hand-banding. This was Wilkinson's pattern 8964 but is found with Clarice Cliff markings and is seen in original features in the press alongside *Bizarre*, so was probably her work (1931) ✿✿

Christine: A table- and teaware design of a central printed floral motif with hatching around the edge, in blue and brown colourways (1934) ✿

Clouvre: Freehand on-glaze floral designs on a light or dark *Inspiration*-glazed ground. Variations include *Tulip* and *Water Lily* and one example is known of *Clouvre Bluebell*, which Clarice based on a *pochoir* print by Edouard Benedictus (1930) ✿✿✿✿✿

Cowslip: Stylized flowers and leaves within a curving boundary edged in *Café-au-lait*. Produced in dominant blue, yellow, green and brown (1933) ✿✿✿✿

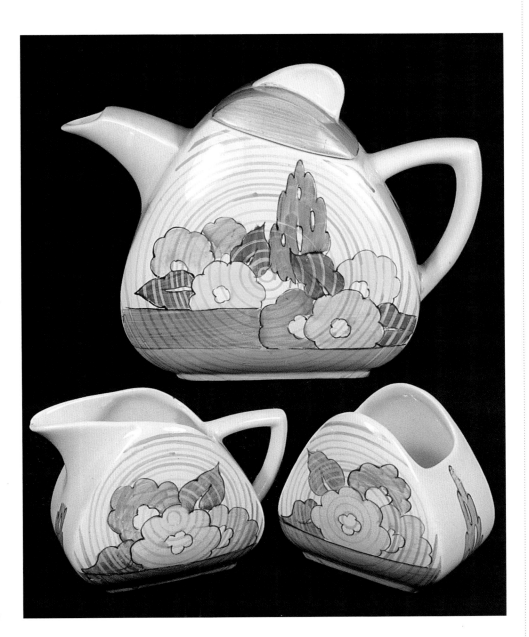

ABOVE: CAPRI ON A TRIESTE SHAPE TEAPOT, MILK AND SUGAR SET, 1935.

OPPOSITE: BLUE CHINTZ ON A WALL PLATE, AND ORANGE CHINTZ ON A CONICAL COFFEE POT.

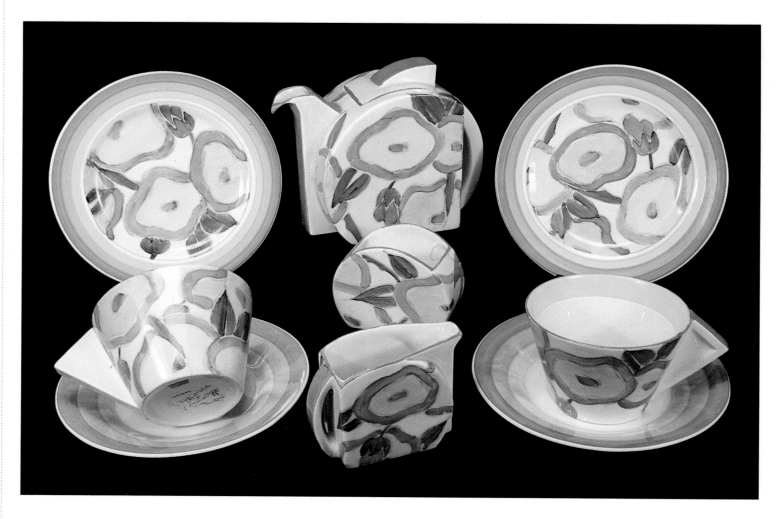

ABOVE: GREEN CHINTZ, THE RAREST COLOURWAY OF THE DESIGN, ON A STAMFORD SHAPE EARLY MORNING SET, 1932.

Crêpe-de-Chine: An all-over printed floral pattern, with hand-painted detail in either dominant green/yellow, blue or red colourways (1933) ✿

Crest: A blue, red and black flower with red-spotted centre with a green crescent surround (1933) ✿✿✿

Crocus: Clarice Cliff's 'signature' pattern of freehand-painted flowers produced from 1928 until 1963 in numerous colourways. The original *Crocus* introduced in 1928 (sometimes called *Autumn Crocus*) featured flowers in orange, blue and purple (1928)

RIGHT: CREPE-DE-CHINE ON A RARE LEDA SHAPE BON BON SET, 1933.

✿✿✿; *Awakening* – a tableware motif of crocus flowers above a wavy line (1932) ✿✿; *Blue Crocus* – all flowers in blue, this was Newport pattern number 6393 (1935) ✿✿✿✿✿; *Gloria Crocus* – underglaze flowers in dull pastel colours (1935) ✿✿; *Peter Pan*

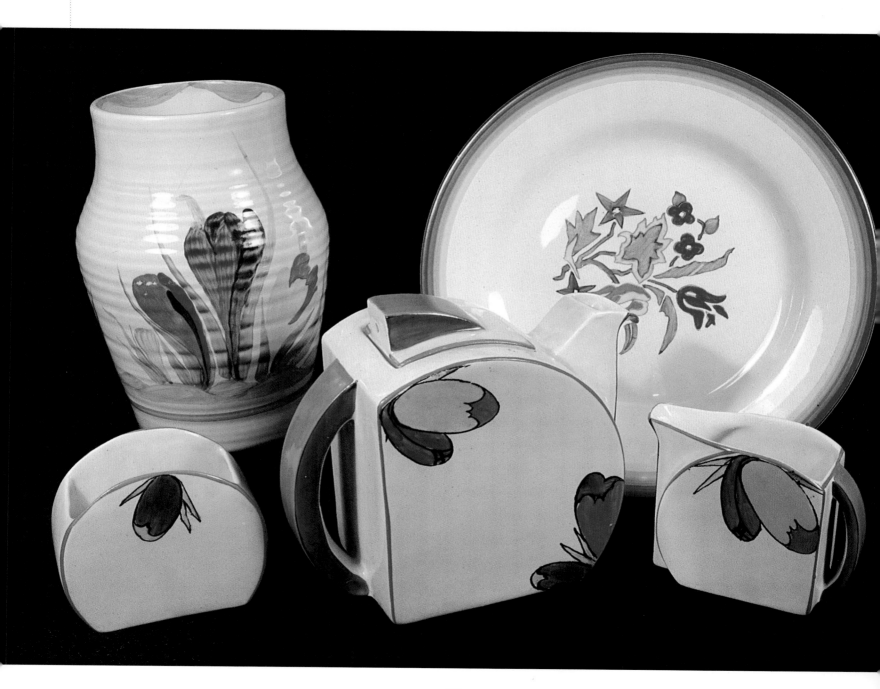

Crocus – freehand crocus flowers against a tree with rabbits underneath, in silhouette (1930–32) ✿✿; *Purple Crocus* – the rarest colourway with flowers in purple (1935) ✿✿✿✿✿ ; *Spring Crocus* – pink, yellow and blue flowers (1933) ✿✿✿; *Summer Crocus* – flowers on a green glaze (1934) ✿✿; *Sungleam Crocus* – flowers in orange and yellow (1931) ✿✿✿

Damask Rose: Ware with pale-pink body and clear glaze featuring either small fruit or floral motifs (1931) ✿

Delecia: The *Delecia* effect was created by mixing colour with turpentine forming randomly coloured runnings over the ware. Various motifs were painted adjacent to this, including *Delecia Daisy* – blue and pink flowers with blue and green runnings (1932) ✿✿✿; *Delecia Nasturtium* – nasturtium pattern with *Delecia* runnings (1933) ✿✿✿✿; *Delecia Pansies* – this has the same flowers as the *Nasturtium* design, but in pastel shades with runnings (1932) ✿✿✿✿; *Delecia Poppy* – large red, yellow and purple flowers with runnings (1932) ✿✿✿✿. The rarest design is *Delecia Water Lily* – an outlined orange and yellow flower, on green leaves, known from a single example on a *Conical* sugar dredger (1932) ✿✿✿✿

Doré: A printed and enamelled flower and leaf design, within a cartouche, as a shoulder pattern. Exclusively produced for Harrods (1930) ✿

Feathers and Leaves: An orange stylized feather shape on a background of green and yellow geometric forms, with a stem and black leaves (1929) ✿✿✿

Flora: A printed and enamelled shoulder pattern of blue and orange buds (1930) ✿✿. A wallmask of a female head garlanded by flowers was also named *Flora*.

Floreat: An orange flower with green and honeyglaze leaves and black detail (1930) ✿✿✿✿

Flower Music: A design featuring sheet music using petals as the notes (1933) ✿✿

Flower Wave: Freehand blue, yellow and green flowers with angular black stems against a blue wavy-lined background (1934) ✿✿

Flowers and Squares: Overlapping purple, green and yellow squares with an orange daisy (1930) ✿✿✿✿

Fuchsia: A printed outline of small flowers and leaves in dominant orange and yellow used as an edge motif on tableware. Also known by its Wilkinson's pattern number 8875 (1930) ✿✿

Gardenia: A bold orange or coral-red flower amidst green and black leaves, with smaller purple and blue flowers (1931) ✿✿✿✿✿

Garland: Orange, yellow and blue 'fried egg'-style flowers all painted freehand on a black ground on the rim or shoulder of ware (1929) ✿✿

Gayday: Orange, rust and purple asters, banded in brown, yellow and green. See also *Sungay* (1930) ✿✿✿

Geometric Flowers: cubist-style yellow, rust, orange, blue and purple flowers on black stems with diamond-shaped leaves (1929) ✿✿✿✿✿

Gloria: A range using simplified versions of *Bizarre* patterns (*Crocus, Tulip*, etc.), produced in underglaze water-colour decoration covered with a *Latona*-type glaze (1930) ✿

Goldstone: A range of ware made with speckled brown clay covered in a shiny glaze, with simple floral or geometric motifs (1933) ✿

Hollyhocks: Pink and lilac flowers, with pale-blue, yellow and brown banding (1936) ✿✿

Hollyrose: Pink and yellow flowerheads with leaves among a blue contour-line pattern (1932) ✿✿

Honeydew: Blue, green and yellow flowers etched in *Rhodanthe* style on tea-, coffee- and tableware. The main retailers were *Hardware Bristol* whose 'HB' mark may be seen on pieces (1936) ✿✿

Honiton: Gently shaded banding with flowers made by dabbing little finger in the wet surface for each petal, then painting in detail, created by Marjory Higginson (1936) ✿✿

Hydrangea: Delicately defined flowers with fine bands, in orange and green colourways. Mainly outlined by Eileen

LEFT: SUMMER CROCUS ON AN ISIS VASE, A WOMAN'S JOURNAL PLATE, AND FLORA ON A STAMFORD TRIO.

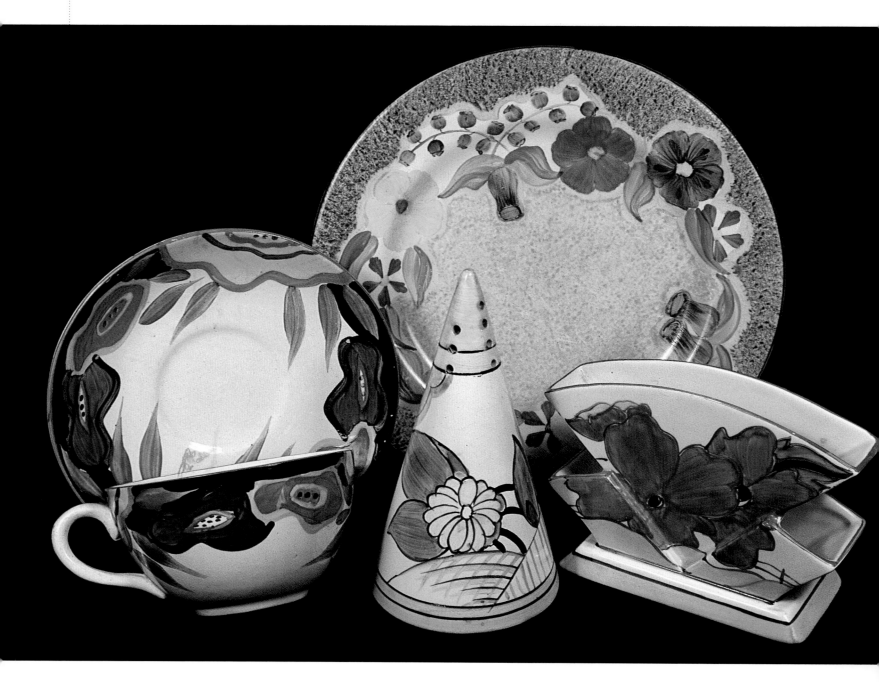

Tharme whose 'E' mark may be found on pieces (1934) ✿✿✿

Idyll: See *Appliqué*

Inspiration: Clarice Cliff's most expensive range where the actual glaze was the featured decoration. Blue, pink, purple and brown metallic oxide glazes painted on to biscuit ware was fired at higher temperatures than *Bizarre*. Designs include *Inspiration Delphinium* – tall flowers against black, next to a decorative ground (1930) ✿✿✿✿; *Inspiration Garden* – a brown-trunked tree in a garden with small flowers (1931) ✿✿✿✿; *Inspiration Lily* – Pink lilies with black leaves against an *Inspiration* ground. Sometimes a red glaze effect appears at the base (1929) ✿✿✿✿; *Inspiration Nasturtium* – a blue, purple and pink version of the *Nasturtium* pattern (1930) ✿✿✿; *Inspiration Rose* – a large pink rose with blue and purple leaves (1930) ✿✿✿✿

Jonquil: Green flowers with a dark-green edge, with smaller green and yellow flowers and green leaves, above tan and green *Delecia* runnings. A rarer colourway is *Lydiat* (1933) ✿✿

Kelverne: Foliage with grey leaves, orange

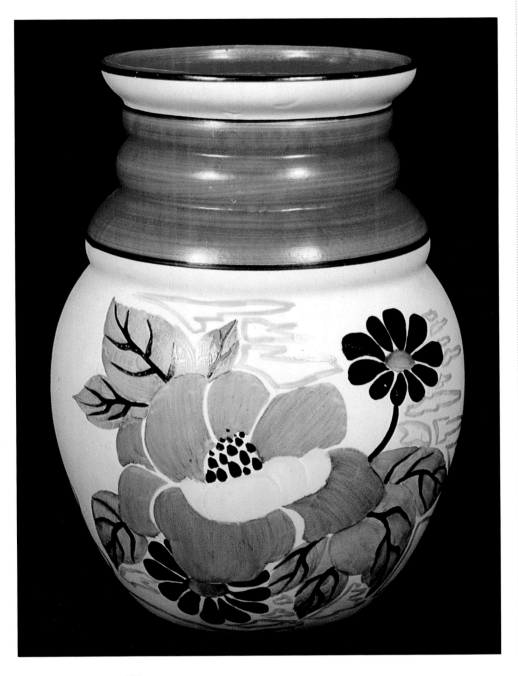

LEFT: GARLAND ON A GLOBE SHAPE CUP AND SAUCER (1929), A CANTERBURY BELLS PLATE (1932), A MOONLIGHT CONICAL SUGAR DREDGER (1933), AND THE REVERSE OF RED ROOFS ON A SHAPE 468 SERVIETTE HOLDER (1931).

RIGHT: A UNIQUE PIECE, LATONA EDEN ON A SHAPE 358 VASE, 1930.

THE FANTASTIC FLOWERS OF CLARICE CLIFF

and red berries and vertical lines (1936) ✿

Kensington: A *Biarritz* tableware motif of stylized tulips with geometric hatching (1936) ✿

Latona: The name given to a milky-coloured glaze introduced in 1929 and used until 1932. On this matt glaze a range of simple yet bold designs were produced, creating a more sophisticated style than standard *Bizarre* ware: *Latona Blossom* – clematis in red and purple with black leaves

(1929) ✿✿✿✿; *Latona Bouquet* – outlined exotic pendant flowers in dominant orange and yellow with blue and green leaves (1929–30) ✿✿✿✿; *Latona Cartoon Flowers* – outlined flowers and leaves with purple flowing underneath, and black diagonal lines, with some pieces having blocks of colour on the neck or rim (1930) ✿✿✿; *Latona Dahlia* – blue, pink and lilac flowers and green leaves with geometric lines, but also an orange colourway is known (1930)

✿✿✿; *Latona Daisy:* large stylized outlined flowers in orange and yellow adjacent to orange and black banding (1929–30) ✿✿✿; *Latona Flowerheads* – stylized flowerheads in *Appliqué* yellow, orange and blue, beside

RIGHT: THE RARE 1928 LUPIN DESIGN ON A FERN POT, WITH A PLATE IN SUNGLEAM CROCUS FROM 1931.

BELOW: LATONA FLOWERHEADS ON A SHAPE 363 VASE, LATONA DAISY ON A 341 AND LATONA ORCHID ON A SHAPE 363, ALL 1929.

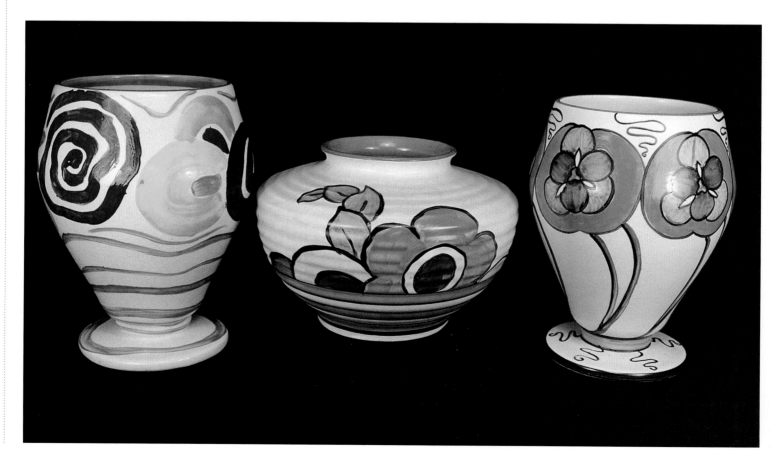

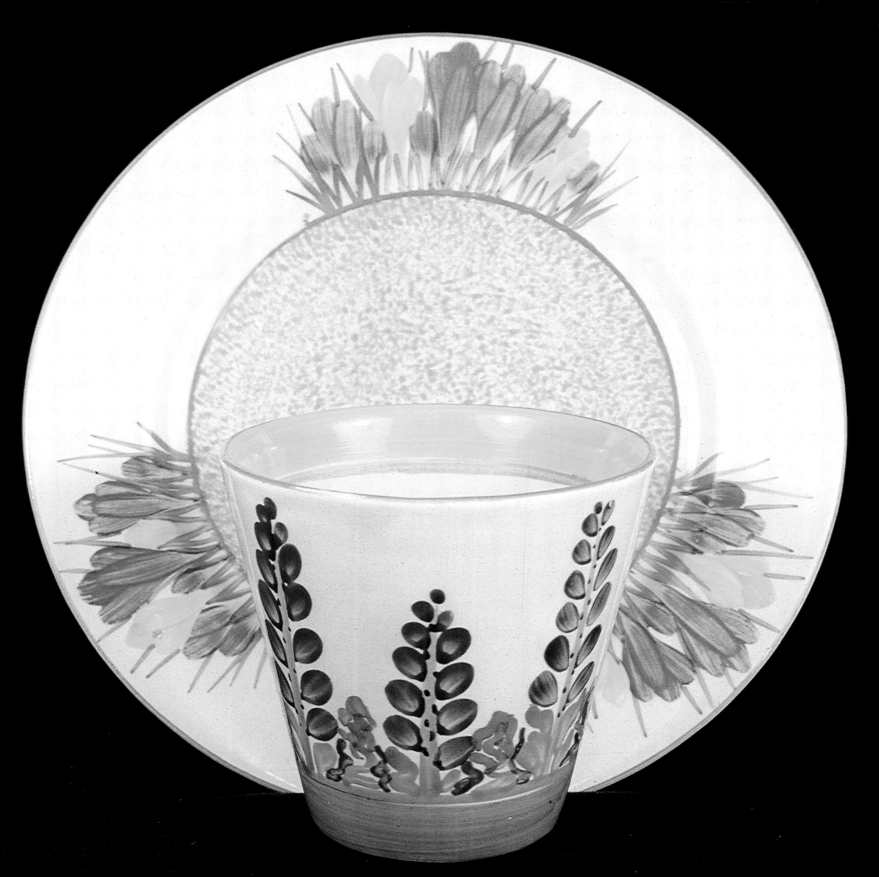

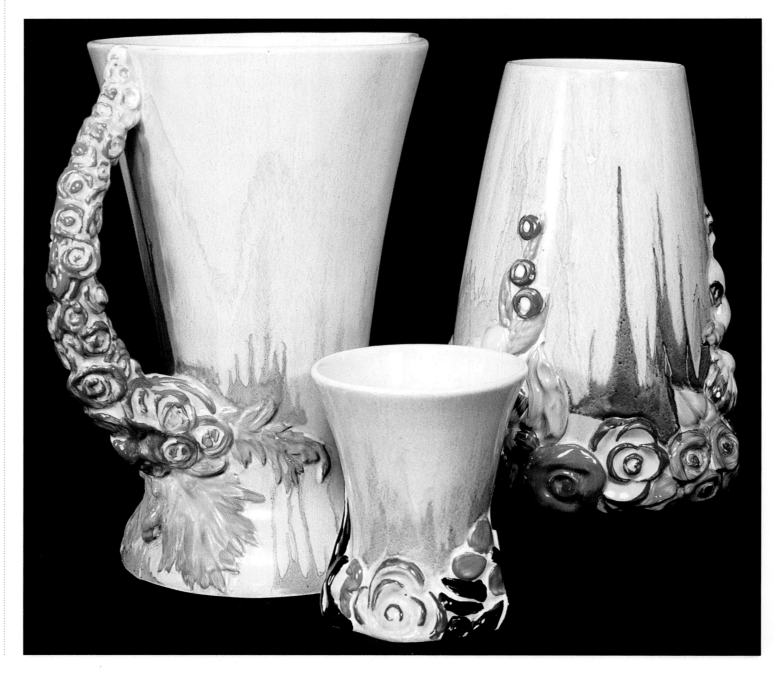

wavy blue stripes (1929–30) ❀❀❀❀; *Latona Gentian* – a three-petalled orange flower, with small round flowers in yellow and blue, all freehand (1930) ❀❀❀; *Latona Inca* – clear flowers outlined in black against a stylized yellow bamboo rod (1930) ❀❀; *Latona Movie Flowers* – red and orange flowers amongst a geometric lining resembling film sprockets, known from one example in Australia (1930) ❀❀❀; *Latona Orchid* – a three-lobed flower in dominant orange with lilac, on sinuous parallel stems (1929–30) ❀❀❀; *Latona Red Roses* – red roses and black leaves completely covering ware (1929–30) ❀❀❀❀; *Latona Shell Flowers* – a rare floral motif so named as the main flower resembles the *Chlamys pecten* shell (1930) ❀❀❀; *Latona Tree* – a black tree-trunk with pendulous multicolour foliage (1929) ❀❀❀. (The *Latona* glaze is also known in rarer grey, tan and pink colourways.)

Le Bon Dieu: A range of shapes resembling tree-trunks or boles painted in brown and green runnings to look like moss and bark. 'I think that I shall never see a form as lovely as a tree' was marked on the base of each item. This range failed to sell so the shapes were then issued in patterns such as *Nasturtium* (1932) ❀

Leaf Tree: A row of stylized flowers beneath a black tree-trunk with giant

orange leaves, based on a similar design by John Butler in his mid-twenties' *Tahiti* series (1933) ❀❀❀

Lily: Brashly drawn lilies and leaves, in orange and brown colourways. The rare *Lily White* has the leaves painted orange, the lily clear, amidst a black background (1929) ❀❀

Lisbon: Overlapping squares with floral motifs and a border of curvilinear style on a *Café-au-lait* ground (1931) ❀❀

Lodore: A printed and enamelled design of flowers in green and yellow with black hatching, used as a tableware pattern (1929) ❀

Love in a Mist: An all-over lithograph design of bold flowerheads, in blue and pink colourways. Also Wilkinson's pattern 9962 (1936) ❀❀

Lupin: Lupin flowers in *Crocus* colours and banding, this is extremely rare (1928) ❀❀❀

Lydiat: Pink-edged orange flowers with smaller yellow flowers and black leaves, above *Delecia* runnings. More common colourway is *Jonquil* (1933) ❀❀

Marguerite: A range of ware with embossed flowers on a honeyglaze ground, as a motif or handle, sometimes with *Café-au-lait* stippling (1932) ❀❀

Marigold: Realistic orange and yellow etched marigolds painted on glaze, on a blue underglaze *Inspiration* ground (1931) ❀❀❀❀❀

Marlow: A printed outline of Marigold-type flowers, against an aerographed and etched blue and yellow background (1933) ❀

Matana: A printed motif of stylized

flowers in pastel shades with blue or green banding. Also Newport Pottery pattern number 6768 (1936–37) ❀

May Blossom: 'Finger-dabbed' flowers, similar to *Honiton,* on a spindly branch with a plain-colour wash background. Known in green, pink and yellow. Most examples painted by Marjory Higginson (1935) ❀❀

Moderne: A cartouche on the rim or shoulder of ware, with a printed outline design, variations include *Jewel* – stylized flowers ❀❀; *Norge* – two fir trees ❀❀; *Odette* – fruit and flowers ❀❀; *Paysanne* – stylized flowers (1929) ❀❀

Moonflower: Green flowers amongst green, grey and yellow geometric blocks. Also known in blue (1933) ❀❀

Moonlight: A stylized pendulous blue tree, with pink, yellow and turquoise flowers

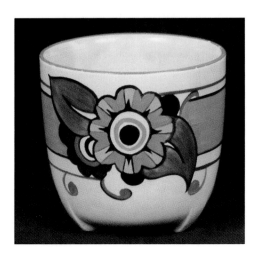

in foreground. Other colourways: *Cornwall,* dominant green; *Devon,* dominant orange (1933) ✿✿✿

Morning: A simple variation of *Rhodanthe* with flowers amidst a band of fine lines covering ware (1935) ✿

Moselle: A large yellow and orange flower with a bulls-eye centre, on a thick red band, this resembles the *Latona* florals (1934) ✿✿

My Garden: A range of ware with heavily embossed flowers hand-painted in enamel colours, with the body of the ware in a variety of shades, including *Azure* – pale blue; *Flame* – red; *Mushroom* – beige; *Night* – black; *Pink* – pink; *Sunrise* – yellow/tan;

Verdant – green (1934–40 and post-war). All ✿✿

Nasturtium: Red, orange and yellow flowers next to a brown *Café-au-lait* ground. Also known with a *Delecia* ground (1932) ✿✿✿✿

Nemesia: A printed and enamelled design of simple small flowers, in orange, yellow and green on handles or corners of ware (1930) ✿✿

Newport: Geometric lines and forms interwoven with small flowers, in coral and blue colourways (1934) ✿✿

Nuage: A fruit or floral motif on a *Café-au-lait*-style ground, but with thickened paint to

give a more textured surface. Designs include *Bouquet; Flowers* (1932) ✿✿

Ophelia: An outline print of a floral basket, with hand-painted colour (1938–41/1946–55) ✿

Pansies: The *Nasturtium* design in pastel shades with *Café-au-lait* or runnings (1932) ✿✿✿✿

Parrot Tulip: Opened tulip petals and leaves painted freehand. Known from factory sample books and one example (1929) ✿✿✿

Passion Fruit: A branch heavy with blue, pink and green fruit and flowers. Also known on a turquoise glaze (1936) ✿

Patina: A range where biscuit ware was 'splattered' with pink or grey slip, then honeyglazed and freehand designs painted on this. Two floral examples known: *Patina Daisy* and *Patina Tulip* (1932) ✿✿

Petunia: The name given to a variation of *Canterbury Bells.* Freehand flowers which are confusingly *not* petunias (1933) ✿✿✿

Picasso Flower: A bold red or orange cubist flower with a blue centre, bisected by a green angular stem. Also known in a blue flower colourway (1930) ✿✿✿✿✿

Pollen: A freehand design of simple brown and orange flowers with pollen flying from them. A *Fantasque* design known from one example (1932 or 1933) ✿✿

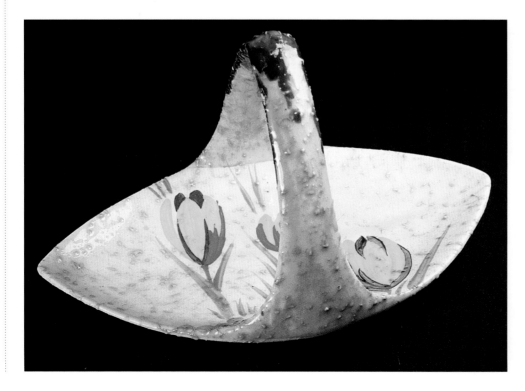

LEFT: PATINA TULIP ON SHAPE 471 BON BON DISH, 1932.

RIGHT: NUAGE BOUQUET ON A FOOTED CAKE PLATE SEEN FROM ABOVE, 1932.

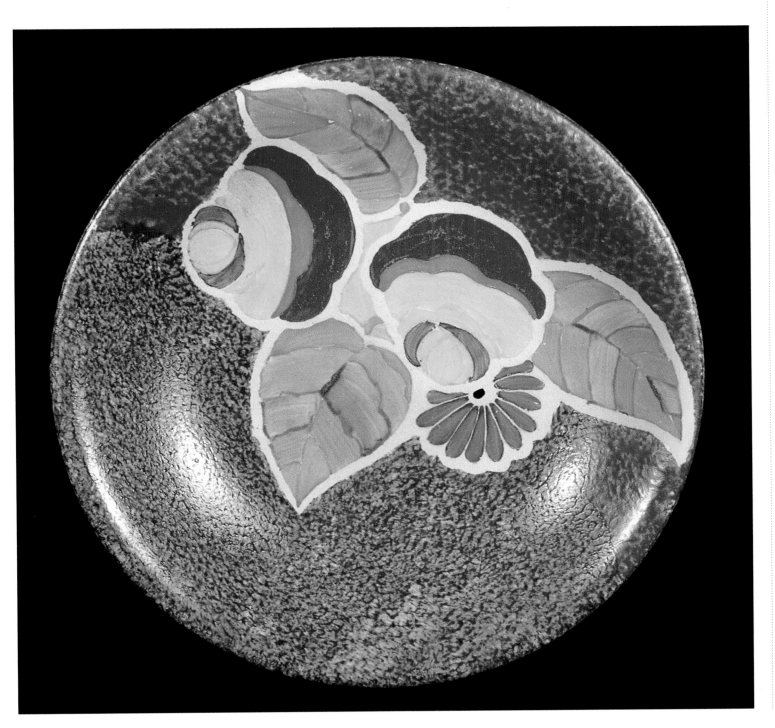

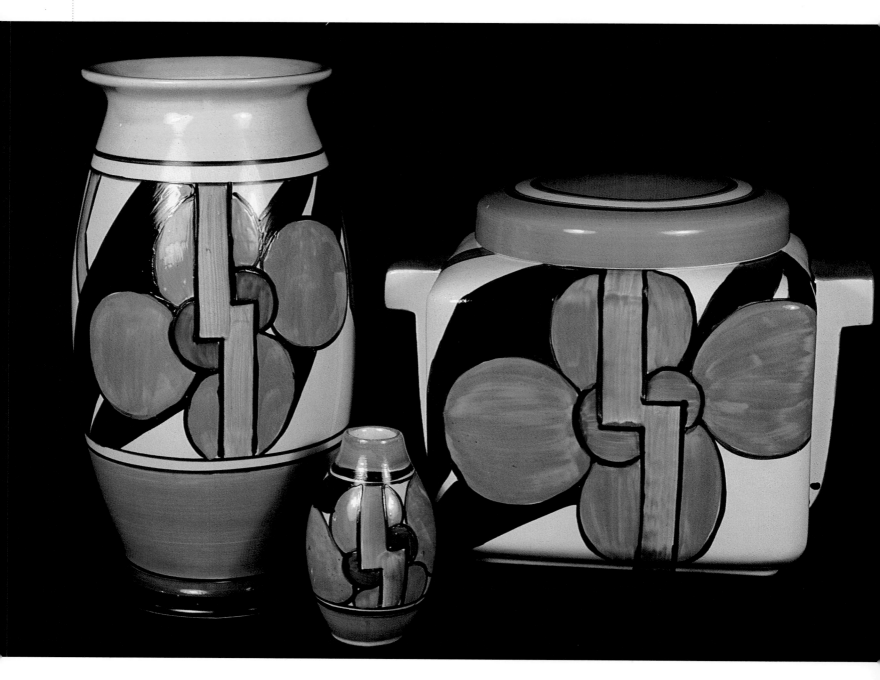

Propeller: Highly stylized flowers resembling a ship's propeller with blue and green leaves and a contour-line effect (1931) ✿✿✿✿✿

Ravel: A tableware motif of a simple cubist flower and leaves in jade and orange, also known as pattern 5799. *Brunella* was a rarer blue and rust colourway (1929) ✿✿

Red Tulip: A single tulip in red and yellow

LEFT: PICASSO FLOWER ON A SHAPE 422 BISCUIT BARREL, A SHAPE 265 VASE, AND A 177 SERIES MINIATURE VASE, ALL FROM 1930.

BELOW: SOLOMON'S SEAL ON A STAMFORD SHAPE TRIO, 1930.

with green leaves and blue stem (1930) ✿✿✿✿

Rhodanthe: Bold flowers etched in orange, yellow and brown, on sinuous stems. Other colourways: *Aurea* – green and yellow; *Pink Pearls* – pink and grey; *Viscaria* – blue and green (1934) ✿✿✿

Scaphito: A range of vases with a body of deeply moulded abstract flowers, painted in a variety of ways (1931) ✿✿

Scarlet Flower: A floral design featuring thick black outlining of large red flowers and a small blue one (1928) ✿✿

Solomon's Seal: A printed and enamelled motif of a sprig of flowers in

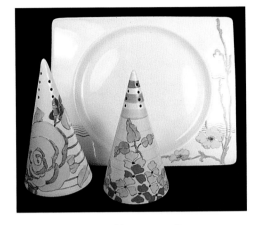

ABOVE: AMBEROSE AND HYDRANGEA ORANGE ON CONICAL SUGAR DREDGERS, AND A BIARRITZ PLATE IN SPEARWORT, 1934.

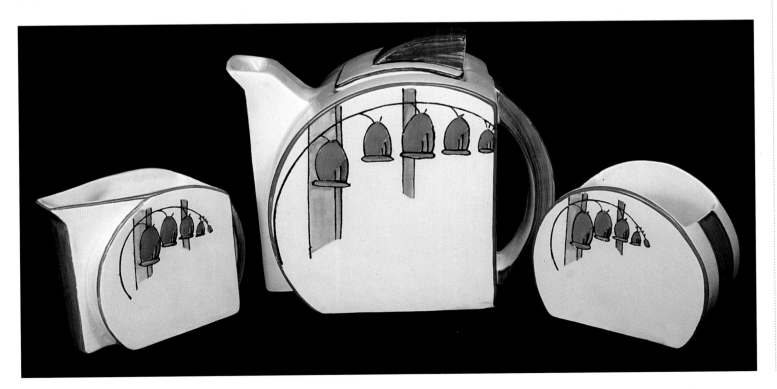

orange, purple, blue and green, often mistaken for *Canterbury Bells* (1930) ✿✿

Spearwort: A *Biarritz* tableware design of yellow flowers (1934) ✿

Summer: The name of a pale-green translucent glaze with standard designs painted on it, which included *Summer Crocus* and *Summer Nasturtium* (1934) ✿✿

Summer Dawn: Freehand orange and blue daisy flowers as an edge motif, produced at Newport Pottery before *Bizarre* was launched. It was attributed the name *Sand Flower* in *Rich Designs of Clarice Cliff* (1927–30) ✿

Sundew: A pink and green colourway of *Honeydew* (1936) ✿✿

Sungay: A variation in blue, yellow and green of *Gayday,* but not exactly the same design (1932) ✿✿

Sunray Leaves: Alternating panels of jade and orange sunrays, with stylized stems and leaves painted amongst them (1929) ✿✿✿

Sunshine: A printed brown outline of flowers painted in yellow and brown, used on dinner-, tea- and coffeeware (1931) ✿

Tartan Poppy: A stylized poppy with petals composed of fine hatching (1935) ✿

Tulips: Essentially, the *Idyll* design without

the lady. A garden scene with a tree, tulips and a distant cottage (1934) ✿✿✿

Wax Flower: Half a blue flower and heavy black lines on an orange and honeyglaze ground. A colourway known from one example features more colours with orange and yellow banding (1930) ✿✿✿✿

Wild Flowers: Blue and purple morning glory flowers with green detail, painted

freehand, primitively, which pre-dates *Crocus* and is known from one coffeeset (1928) ✿

Windbells: A sinuous tree with black trunk and blue lenticular foliage, against a wavy green and yellow curved background (1933) ✿✿✿✿

Windflowers: A circle of yellow, blue and brown freehand-painted flowers next to a *Café-au-lait* ground, known from one example, a charger. (Probably 1932 or 1933) ✿✿✿✿

Woman's Journal: A printed and enamelled floral motif, in orange, red and blue, with blue and orange banding. A tableware pattern offered exclusively to readers of this magazine (1931) ✿

Woodland: A printed and enamelled tree with orange and green foliage, above blue and purple flowers. Wilkinson's pattern 8869 it was issued with Clarice Cliff markings (1931) ✿✿✿

Yellow Orchid: A hand-painted yellow flower against an orange aerograph ground (1934) ✿

Yellow Rose: Yellow flowers with tan petals, adjacent to a motif of brown and orange lines. A tableware design (1932) ✿

ABOVE: THE 1928 WILD FLOWERS DESIGN KNOWN FROM JUST ONE EXAMPLE, A TANKARD SHAPE COFFEESET.

RIGHT: WAX FLOWER ON A SHAPE 358 VASE, AND BLACK FLOWER ON A SHAPE 342.

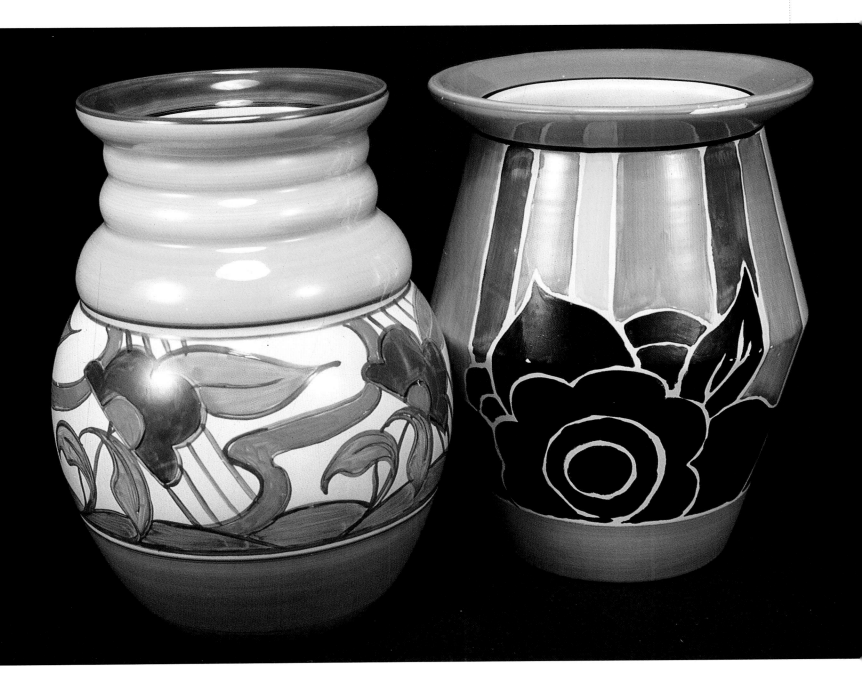

FLORAL DESIGNS IN AUSTRALIA AND NEW ZEALAND

Clarice Cliff was so prolific in the export market in the thirties, and again in the fifties, that designs found in New Zealand and Australia differ from those marketed in Great Britain. In New Zealand a number of uncatalogued simple floral designs have been found on *Biarritz* tableware, which appear to date from 1935 to 1941, and from 1946 to 1955. Collector Greg Slater has researched Clarice Cliff and Wilkinson's pottery sold in Australia, and continues to find and catalogue new floral patterns. The brief listing below is confined to the more significant pre-war patterns that Southern Hemisphere collectors are liable to find.

Many of these will not be found in Great Britain. The listing includes some patterns that were not definitely Clarice's work.

Aura Daisy: Small flowers randomly painted over ware with an etched edge, this variation on Clarice's Aura is mainly seen in New Zealand (1935 onwards)

Honeybloom: A floral motif printed in yellow and enamelled, with a custom *Honeybloom* backstamp, this was also Wilkinson's pattern number 9359 (probably 1933)

Kyzia: A freehand motif of flowers was also Wilkinson's pattern number 8758 (1930)

Lourie: A freehand motif of a brown trellis with a few green leaves and small blue flowers. Was also Wilkinson's pattern number 8757 (1930)

Poppies: A printed and enamelled design of flowers which was also Wilkinson's pattern number 8504 (1928). See also *Delecia Poppy*

8332: A motif of printed 'Dog Roses' hand-painted in pink, yellow and red, below a band of gold bubbles, this was a Wilkinson's pattern number (1927)

9049: Freehand blue leaves, with small coral flowers and green lining, this was a Wilkinson's pattern number (1932)

Right: A selection of Clarice Cliff floral pieces from collections in New Zealand and Australia. Braidwood on a Leda shape plate (1935), Gardenia Orange on a shape 265 vase, a Picasso Flower Red octagonal plate, (1930), a Blue Crocus jampot (1935), a Latona eggcup, a Clarice Cliff Conical milk jug decorated in a Wilkinson's design, a Bon Jour sugar dredger in Moonflower Blue (1933), and Red Tulip on a shape 186.

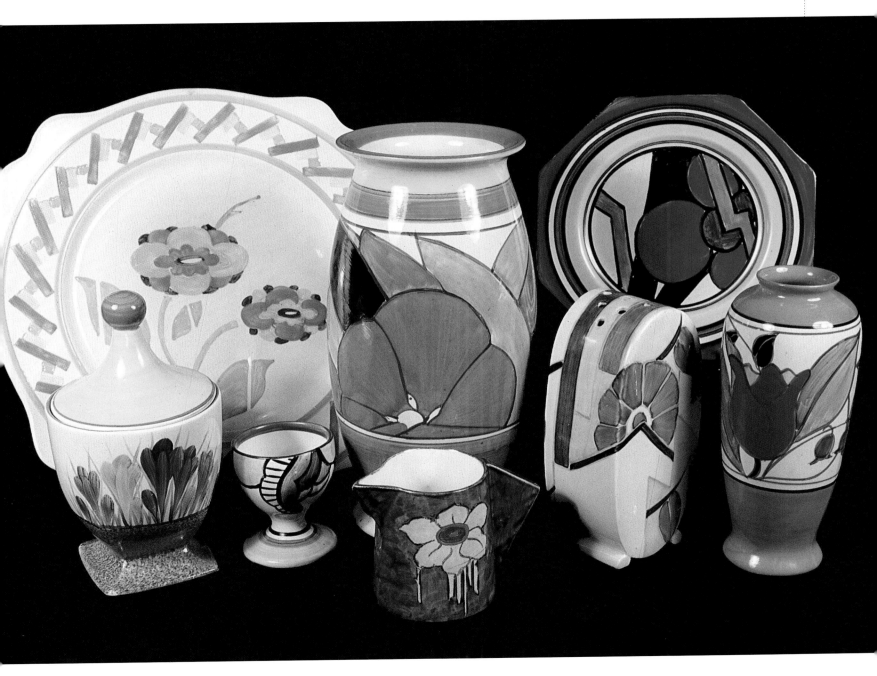

FLORAL LANDSCAPES

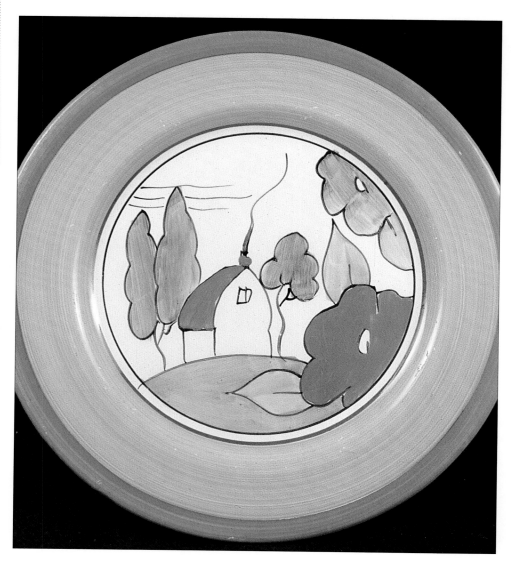

Some of Clarice's landscape designs rely heavily on the use of flowers. Although Clarice's 1929 to 1930 landscapes such as *Trees & House, Orange House, Appliqué Lucerne* and *Autumn* did not have floral elements, from 1931 many of her landscapes started to incorporate very noticeable flowers. The following are a small selection of these: *Alton, Chalet, Appliqué Garden, Fragrance, Limberlost, Appliqué Monsoon, Appliqué Palermo, Poplar, Red Roofs, Sandon, Trallee.*

A complete listing of Clarice's designs will be featured in *Clarice Cliff: The Art of Bizarre,* to be published in 1999.

LEFT: A POPLAR PLATE. THIS 1931 DESIGN FEATURED LARGE FLOWERS IN THE FOREGROUND AND A TYPICAL CLARICE CLIFF COTTAGE IN THE DISTANCE.

RIGHT: FRAGRANCE ON A LYNTON SHAPE TEA SET, 1935.

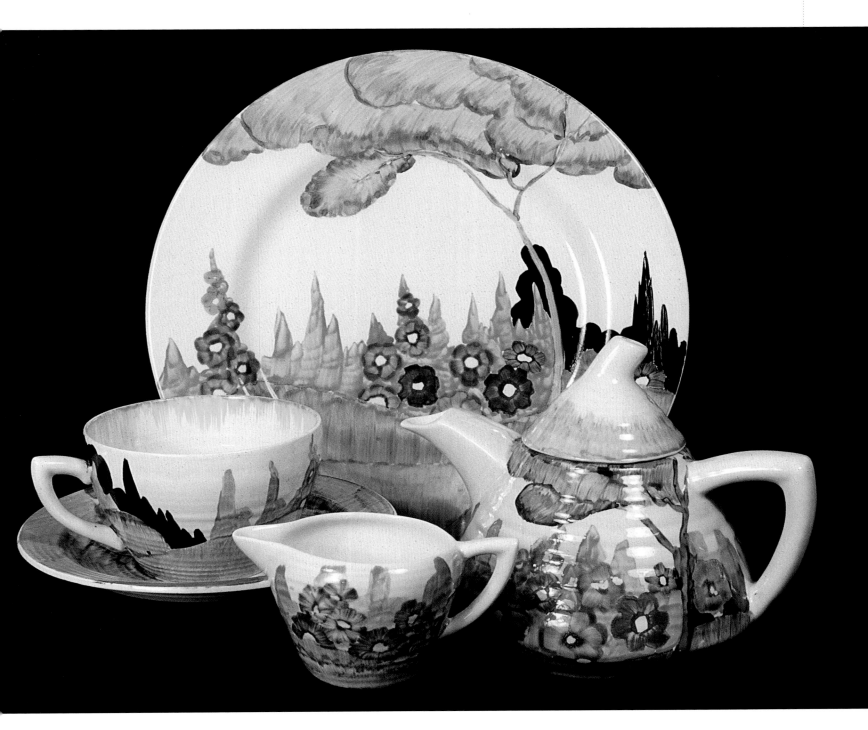

THE FLOWER TRAIL

Chetwynd House: Professor Flavia Swann receives many requests from scholars, collectors and admirers of Clarice Cliff, Sir Raymond Unwin and Barry Parker. Should you wish to visit, please write for an appointment to: Chetwynd House, Northwood Lane, Clayton, Newcastle, Staffs ST5 4BZ.

Hand-Painting Seminars and Demonstrations: These are held by Terry Abbotts. He specializes in Art Deco subjects, and also the *Crocus* pattern as taught to him by the original *Crocus* paintress Ethel Barrow. He can be contacted on 01782 771453.

Museum Displays of Clarice Cliff Pottery: The Metropolitan Museum of Art, 1000 Fifth Avenue, New York, NY 10028 (212 879 5500) has had a collection of Clarice Cliff ceramics for over ten years, which is normally on show in the Design department. The Royal Ontario Museum, 100 Queen's Park, Toronto M5S 2C6 (416 586 8000), has a small collection of Clarice Cliff pieces. A section is currently being developed for the 20th Century Gallery to be built at the Wedgwood Museum at Barlaston, Stoke-on-Trent ST12 9ES (01782 204141). The Potteries Museum (formerly Hanley Museum and Art Gallery) have a small selection of Clarice Cliff ware on display at Bethesda Street, Hanley, Stoke-on-Trent ST1 3DW (01782 232323). Brighton

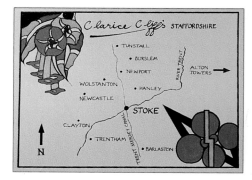

Museum & Art Gallery have Clarice Cliff ware, including some of her own pieces donated after their 1972 exhibition at the Royal Pavilion, at the Pavilion Buildings, Brighton, Sussex BN1 1EE (01273 290900).

Art Deco Fairs: These are now held every weekend in Britain, and are listed in the local press and the *Antiques Trade Gazette*. Most major Clarice Cliff dealers stand at these fairs. Many of the dealers are also Clarice enthusiasts so do ask them about their stock.

All Clarice Cliff Auctions: In May and November each year, Christie's South Kensington (0171 581 7611) hold specialist auctions with 300–500 lots. The fully illustrated catalogues and viewing days are an excellent way to add to your knowledge. Other London auction houses who sell Clarice Cliff are Bonham's (0171 393 3942), Philip's (0171 629 6602), Sotheby's (0171 293 5000). The only auction house outside Central London that regularly holds Clarice

Cliff sections is Gardiner Houlgate of Bath (01225 447933).

Clarice Cliff Collectors Club: Founded in 1982, the club is for real devotees and has members around the world. The *Review*, issued three times a year, has articles about Clarice, *Bizarre*, archive material and auction news. Limited editions of Clarice Cliff ware are available exclusively to members. At the annual Convention members can attend talks, consult the archives, and enjoy the reunion of the original *Bizarre* 'girls'. For details send a sae to Subscriptions, C.C.C.C. Fantasque House, Tennis Drive, The Park, Nottingham NG7 1AE; in New Zealand, send it to CCCC c/o Burlington Berties, 91 Great South Road, Auckland, New Zealand; in Australia, write to CCCC, 24 Parade Street, Albany, Western Australia 6330. Louis and Susan Meisel are the longest established Clarice Cliff specialists in North America, and have been active members of the Clarice Cliff Collectors' Club since 1984. They wrote *Clarice Cliff: The Bizarre Affair* with Leonard Griffin in 1988. Their gallery is at 141 Prince Street, New York, NY 10012 (212 677 1340).

The Agora: This Australian decorative arts journal is available world-wide and regularly covers Clarice Cliff and Wilkinson's. Subscription details from PO Box 3503 Weston, Australian Capital Territory, 2611 Australia.

WITHDRAWN

ASSISTANT GARDENERS

I must wholeheartedly thank Clarice's niece Nancy for giving us a new insight into the real Clarice Cliff. Norman Smith shared his memories of Clarice and Colley, who were close friends of his as well as his employers for many years. I was fortunate to have the advice of Peter Goodfellow, grandson of Charles Goodfellow, on the early years of Chetwynd House, and the current owner Professor Flavia Swann gave generously of her time and expertise. Dr Richard Brumpton painstakingly identified the flowers that grew in Chetwynd House's garden throughout the seasons. Needless to say, I am most indebted to Clarice's original *Bizarre* 'girls', and Jim Hall, Eric Grindley and other Newport Pottery staff, who have shared thousands of memories with me since 1981.

Thanks also to alll the Clarice Cliff Collectors Club (CCCC) members who provided information or allowed me to photograph their pieces. In Great Britain: David and Barbara Gilfillan, Mick and Linda Griffiths, Jo and Terry, Shirley and Michael, Bill Taylor, Michael Hogger, David Wilkins, Greg and Julie, Ron and Teresa Sproit, Roger Hopkins, Phil Woodward, Muir Hewitt, Rachel Steel, and Jonathan & Alan of Banana Dance. In North America: Richard Kutner, Judi and Herb Edelberg, Susan Scott, S & B, and particularly my dear friends Julie and Sandy. In Australia and New Zealand: Greg Slater, Bernadette and Kevin Straka, Garth Wilshere, Dr Nicholas Nicolaides, Ken and Beverley, Shane and Henri, Ila Bell, Dr Kathy King, Carole Hansen, Lois and Albert van Velzen, Russell and Erik of Classic Promotions and particularly Dr Daniel Brodie, and Jonathan, Lynley and Georgie Drain.

Archive photographs are courtesy of Nancy Cliff, Norman Smith, the *Bizarre* 'girls', the Stoke-on-Trent City Archives and Stoke-on-Trent Archive Service, and the Clarice Cliff Collectors Club archive. Excerpts from Clarice's letters (which may not be reproduced without written consent) are courtesy of the Clarice Cliff Collectors Club. Mark Wilkinson and Michael Jeffery of Christie's South Kensington helped grade the designs. Particular thanks to Mike Slaney for his artistic touch on the photographs and, finally, thanks to Doreen Jenkins, my oldest friend, both for the 'Bouquet' and her 'seeds of wisdom' which helped me with the whole book. L.G.

('Clarice Cliff' and 'Bizarre' are registered trademarks of Josiah Wedgwood and are used with permission.)

BIBLIOGRAPHY

Battersby, Martin, *The Decorative Thirties* (Studio Vista 1969)
Christie's South Kensington, Clarice Cliff auction catalogues 1983–98
Green, Richard, Des Jones and Leonard Griffin, *Rich Designs of Clarice Cliff* (Rich Publications 1995)
Griffin, Leonard, *The Reviews of the Clarice Cliff Collectors Club* (CCCC 1982–98)

Griffin, Leonard, *Taking Tea with Clarice Cliff* (Pavilion 1996)
Griffin, Leonard, and Meisel, Louis K. and Susan Pear, *Clarice Cliff: The Bizarre Affair* (Abrams [US]/Thames & Hudson [UK], 1988)
Hopwood, Irene and Gordon, *The Shorter Connection* (Richard Dennis Publications 1992)

Johnson, Kay and Peter Wentworth-Sheilds, *Clarice Cliff* (L'Odeon 1976)
Ross, J.E., *Letters from Swansea* (Christopher Davies Publishers c. 1954)
Smith, Mary Ann, *Gustav Stickley: The Craftsman* (Dover Publications 1983)

GLOSSARY

Bander and liner a decorator who puts fine lines or thicker bands of colour on ware by applying the paint on brushes of different thicknesses whilst rotating the ware on a potter's wheel

Biscuit the name given to ware which has had just one firing to harden it, before it is glazed

Bottle ovens kilns built of brick and fired by coal which often reached a height of forty to fifty feet

Early Morning set a teaset for two comprising teapot, milk and sugar, two cups and saucers, and just one or two plates.

Designed to be used in the bedroom for the first cup of tea of the day they were also popular with housewives for use when a visitor called

Enamel kiln a small oven used to fire ware with enamel decoration on-glaze

Enameller a decorator who applied on-glaze enamel colours either *freehand* or within another decorator's *outline*

Fancies small non-essential items such as cauldrons, sabots, ink wells, bookends, which constituted an important part of Clarice Cliff's range

Freehand a decorator who applied a

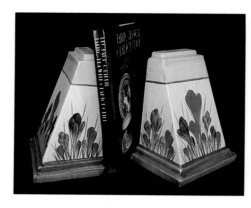

design with no existing guidelines such as *Crocus,* or *Gayday*

Gilding painting fine gold lines on pottery

Glost ware which has been glazed but is undecorated, this was stored in the glost warehouse

Honeyglaze the tradename for the clear glaze that was used on Newport Pottery and Wilkinson's ware. This had one per cent iron oxide content, hence the name and colour

Kilns smaller versions of bottle ovens where glazed or enamelled ware was fired

Lithography the art of applying *printed* transfers on ware as the main decoration

Missus a woman who supervised a decorating shop and also trained the

workers in the necessary techniques. The 'missus' was generally an experienced paintress herself

On-glaze decoration applied to the ware *after* it had been fired and glazed, which was then re-fired in the *enamel kiln*. This was the main style of decoration used on Clarice's hand-painted ware

Pochoir a printing process popular in France used to produce fine quality prints in many colours

Potbank the Staffordshire name given to a pottery factory as in the early years they had a 'bank' of clay outside, and made 'pots'

Shards broken pieces of ware which formed mounds – *shard* rucks – covering acres of land adjacent to the factories. This is pronounced 'sherds' in Staffordshire

Shop the Staffordshire term for a room in a factory dedicated to one process, such as a decorating shop or a lithography shop

The Potteries a collective name for the six Staffordshire towns of Hanley, Tunstall, Longton, Burslem, Fenton and Stoke

Underglaze ware decorated in the *biscuit* state before it was glazed, the traditional way of decorating printed ware, only rarely used by Clarice Cliff in the Thirties